Invisible No More

Invisible No More

A Photographic Chronicle
of the Lives of People
with Intellectual Disabilities

Photographs and Text
by Vincenzo Pietropaolo

Foreword by Wayne Johnston

Essay by Catherine Frazee

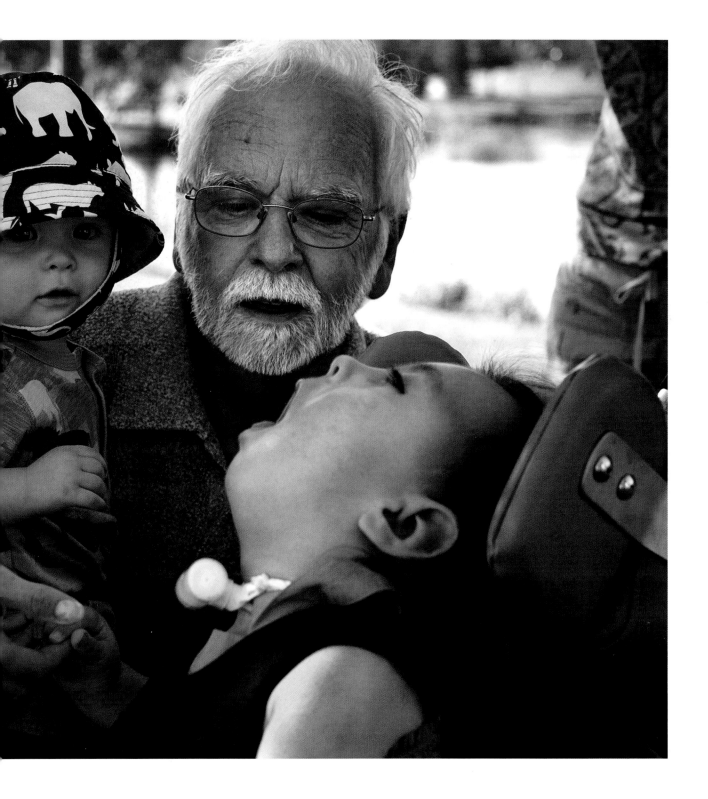

RUTGERS UNIVERSITY PRESS
New Brunswick, New Jersey, and London

Library of Congress Cataloging-in-Publication Data

Pietropaolo, Vincenzo.

Invisible no more : a photographic chronicle of the lives of people with intel-

lectual disabilities / photographs and text by Vincenzo Pietropaolo ; fore-

word by Wayne Johnston ; essay by Catherine Frazee.

p. cm.

Includes bibliographical references.

ISBN 978–0–8135–4768–8 (hardcover : alk. paper)

1. People with mental disabilities

2. People with mental disabilities—Pictorial works.

I. Frazee, Catherine. II. Title.

HV3004.P535 2010

362.3—dc22

2009030963

A British Cataloging-in-Publication record for this book

is available from the British Library.

Visit our Web site: http://rutgerspress.rutgers.edu

Manufactured in China

TEXT DESIGN AND COMPOSITION BY JENNY DOSSIN

Dedicated to the memory of people
with intellectual disabilities
who died confined inside mental institutions,
and were buried in unmarked graves,
thus stripped even of their identity forever.
Who were they?

Contents

PHOTOGRAPHS AND STORIES

Foreword

Invisible No More. As the main title plainly and unapologetically makes clear, this book seeks to change the way we see—or rather don't see—something. But the subtitle tells us that that something is not a thing, or even a group of things, but a group of people.

"People with intellectual disabilities" is a phrase that, because it is relatively new and for other reasons, has been dismissed by some as being too "correct," too much like the sort of phrase that issues from the mouths of those whose hearts supposedly bleed for everyone and everything. But, as everyone ever born has learned the hard way, words matter. Words do more than alter our perceptions, they determine them, fix them in shapes and forms, and give us an all-too-common language that excuses us from having to think for ourselves.

A word or phrase that is widely used is assumed to be widely accepted. But it is almost always the case that the opposite is true.

So it is always worthwhile to look closely at language. "People with intellectual disabilities." Every word is chosen for a purpose. The order of the words is chosen for a purpose. "People" comes first of all because "they" are people first of all.

We know "them," people with intellectual disabilities, by the words we all wish we had never used yet go on using lest, by objecting to their use, we come across as being too earnest, too serious, unable to take a joke at what isn't even our expense but someone else's. Come on, play along. It's what everyone does, right?

And so we do play along until later, when we're alone, and there surfaces a pang of self-ashamed regret, which, though it doesn't linger, cannot be suppressed.

This book is composed of photographs as well as words. Photography is another kind of language. The eloquence of Vincenzo Pietropaolo's photographs is evident even to those who will tell you that they do not "know" photography. He has traveled the country of Canada to gather the images and stories of a group of people that he loves and honors by making them the subject of his art. And they have honored him by speaking to him and allowing him far enough into their lives that, with his pen and camera, he finds in each of them the elusive something so that makes us all unique.

So we know "them" also by how they look, though we either never look at them for long, or do so for so long that to "see" them is impossible. A seeming paradox.

We see them on the street, on the buses and the subways, in gymnasiums and places of play and work. Sometimes they are alone. Sometimes they seem to be alone even when others press against them from every side.

We see them with their parents, who try, for the sake of their children and themselves, not to notice or to mind when, for the umpteenth time, some passing, well-intended person gapes, then looks away, as if looking might cause offense.

In which case, we do *not* see them. We see through them. Around them. In the

photographs of our mind, they are absences, blank spaces, areas of erasure around which what we think of as "life" takes place. They are an invisible minority.

This book and its maker seek to change that.

The title is bravely naïve and free of arrogance and irony. Vincenzo Pietropaolo is not concerned with the possibility of failure, and he has not worked in the hope of personal reward. He sees this book as but a step along the path to visibility for people with intellectual disabilities. He seeks to make visible the living and the dead, the historical present and the historical past—the story of the thousands who died unacknowledged, unremembered, in hospitals and foster homes.

There is nothing left for me to do but accompany him to the footlights of the stage and then withdraw into the wings and watch and listen, for I know that those in the audience who also watch and listen will look at "them" after the curtain falls and know them and see them for the first time.

Wayne Johnston
May 2009

Invisible No More

Genius: An Introductory Essay

CATHERINE FRAZEE

Trajectory

Genius. Pl. genii, geniuses. [a. L. *genius*, f. **gen-* root of *gi-gn-re* to beget, Gr. to be born, come into being.] The tutelary god or attendant spirit allotted to every person at his birth, to govern his fortunes and determine his character, and finally to conduct him out of the world; also, the tutelary and controlling spirit similarly connected with a place, an institution, etc.

—*Oxford English Dictionary*

"Way t'go, Genius," the surly youth snarls, meaning quite the opposite. Duly insulted, his teammate shrugs, then steps over the fence to retrieve the foul ball.

The chosen epithet lobs the word "genius" further still on a centuries-long migration. In a usage familiar to everyone who has slapped their own forehead after some trivial blunder, "genius" rebukes us for our shortcomings and tightens the twine that binds us to our errors. For a moment, no longer the hapless doer of something foolish, we become the foolish thing. For a moment we squirm, not just because we are made foolish, but because of the preposterous irony that equates our fumbling, faltering selves with such a rare and fine quality as genius.

What exactly is genius? Ask the question today, and the answer will probably be some variant of "a person with rare and exceptional brilliance." A genius is someone who has achieved mastery of a subject or practice, someone of extraordinary expertise, someone who exceeds expectations of what can be done.

Random Internet searches for "genius" yield a not-so-random pattern of result. Albert Einstein. Wolfgang Amadeus Mozart. Leonardo da Vinci. Thomas Edison. William Shakespeare. Mostly men, mostly dead, and mostly cherished by history and scholars alike. Enthusiasts compile lists of geniuses and debate the borderline cases. Devotees extend the category of genius to athletes, entertainers, soldiers, statesmen, and criminals. Hucksters offer training programs and dietary supplements guaranteed to promote us and our children to the ranks of genius. Dubiously credentialed specialists chronicle the correlations between genius and madness, and meticulously calculate the measure of genius in persons living and dead.

Genius is a rare and coveted prize, however attained. Therein may lie the most troublesome feature of the word's contemporary trajectory. Somewhere in the passage of centuries from its earliest origins, "genius" became an attribute, something that one has, or far more often, does not have. Along the way, in the thick jungles of consumer culture, genius became a commodity, a form of capital that could be traded for privileged goods or status.

We are, it seems, a long way from ancient Rome. There, in the earliest known uses of the word, "genius" denoted the attendant or guiding spirit of a person or place. Every

living being was endowed with his or her own genius, a personal blessing of protection and inspiration that remained faithful and present from life's beginning to its end. Individuals both worshiped and celebrated their genius, offering "libations of wine, incense, and garlands of flowers" on birthdays and other occasions.[1] No one was without genius— a unique and personal divinity described by the poet Horace as holding the key to each person's character, shaping fortune, temperament, and destiny.[2]

How did genius travel from Horace to horseplay? How can the same word express the lofty thoughts of a Latin poet and the disdain of a schoolyard ruffian? And what trajectory of meaning could possibly account for the insertion of an essay about genius in the introductory pages of a book of photographs of people with intellectual disabilities?

The answer lies in the vast social histories spanned by a single word, and the dynamic relationship between language and perception. Words are supple beneath the friction and grind of the ideas that shape our world. As genius has changed, so have we.

In the restless force of civilizations shifting and churned, genius indeed was transformed. Classical beliefs about genius fell into disrepute during the Middle Ages, giving way to Christian formulations of angel and demon. Generations later, during the great surges of Renaissance culture, genius took on secular meanings reflecting the passions and the dispositions of the time. As artists and scholars broke away from religious and social orthodoxies, genius would be celebrated as the quintessential expression of *human* thought and creation.

In an essay on the "power of genius," Shel Kimen notes that books and letters from the sixteenth century refer alternately to "the genius of Michelangelo" and "Michelangelo, the genius," thus marking this transition from a divine endowment to an intrinsic quality of character.[3] Gifted Renaissance artists came to be seen as powerful individuals who could summon genius through acts of will. Genius became the brass ring, the prize of the mighty and heroic—possessed by few, the envy of all.

Genius, additionally, began to lose its innocence. In a postfeudal, mercantile economy, genius would interlace strongly with prosperity. Kimen speculates that an appetite for luxury among the Renaissance period's emerging merchant class established genius as a lucrative asset. The value of what one owned was differentiated not only by the materials from which it was constructed, but also by the time and skill of the artisan who produced it. Value—and price—were boosted by genius. Put plainly, "It was better to have your church painted by Michelangelo than by a less famous artist."[4]

Later still, when Enlightenment philosophers turned their attentions to the question of genius, the label secured its designer cachet. Genius became more rarefied still. In essays and correspondence spanning thirty years of detailed reflection, Immanuel Kant's preoccupation with the question of genius culminated in a definition best captured in a single phrase: "exemplary originality."

Kant's criteria for genius were twofold: superior *powers of invention*, manifest in creations *worthy of emulation*. He took great pains to distinguish "mimicry" and other learned or imitative forms from true genius. By his criteria, even a scientist with the brilliance of Newton was no genius, for by definition, the scientific method was stepwise and repeatable. As Kant explained, "The greatest inventor differs only in degree from the most laborious imitator and apprentice."[5]

True genius, according to the wisdom of the era, conformed to no rule and followed no lead. It could not be learned, but instead would erupt, spontaneous and radically original. Originality was its "primary property." One of Kant's contemporaries, Johann Georg Hamann, wrote of the near impossibility of such absolute originality. Hamann

reasoned that the genius must "cultivate a thoroughgoing ignorance," breaking free of every convention of human thought and every echo of history.[6]

This pairing of genius and ignorance is startling to the modern ear. We do not easily warm to the notion that education might impede genius. Yet the reasoning of Enlightenment philosophers is not easily refuted. The more that we know, the more that we learn, the more that we accumulate in reservoirs of memory and intellect, the more compromised our originality, and the more vulnerable we are to Hamann's universal "law of imitation." Wealth of knowledge and experience would form a kind of rampart, securing its possessors against the insurgencies of genius.

Radical originality. Thoroughgoing ignorance. The restless mind pauses, startled and yet somehow freed by an unexpected logic. It is an experience much like the encounters that await in the photographs to follow. The restless eye will pause, seized and, at the same time, liberated.

But in the decades that would precede Vincenzo Pietropaolo's photographic odyssey, genius would make a considerable detour.

Deviation

> Genius, therefore, glitters like a momentary phenomenon
> which appears and disappears at intervals, and vanishes
> again. It is not a light that can be kindled at will and kept
> burning for a period of one's own choosing, but rather it
> is like a spark-scattering flash which a happy seizure of
> the spirit entices from the productive imagination.
>
> —Immanuel Kant, *Anthropology from a*
> *Pragmatic Point of View*

Like the weathered bedrock beneath us, language bears the divots and abrasions of the glacial shear of culture. Nowhere is this more evident than in genius's deadly flirtation with the science of eugenics.

When Charles Darwin published *On the Origin of Species* in 1859, the worlds of philosophy and science were taken by storm with the groundbreaking assertion that species evolve through processes of natural selection. As the full implication of this theory excited a voracious international audience, Darwin's cousin, Sir Francis Galton, began to question how principles of natural selection might apply to humans. Galton was fascinated by the notion that human characteristics might form part of the inheritance of successive generations in much the same way as the plant and animal traits described by his biologist cousin.

Like many of his contemporaries, Darwin had always maintained that "men did not differ much in intellect, only in zeal and hard work."[7] Galton, however, who lacked neither zeal nor diligence, preferred to think of genius as an ability "that was exceptionally high and *at the same time inborn*."[8] Convinced that superior attributes of character and intellect were passed down through generations, and drawing support for this intuition by the signs of hereditary talent in his own family, Galton undertook an analysis of data collected from published biographies and *Times* obituaries, tracing the lineage of "eminent" men in Europe.[9] Systematically calculating averages and deviations within the data, he concluded that "there are more than a hundred times as many relations of eminent men who are themselves eminent, than the average would require."[10]

Galton's conclusions, published in 1869 in an influential text entitled *Hereditary*

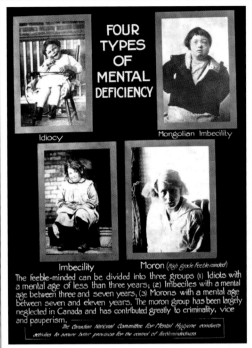

FOUR TYPES OF MENTAL DEFICIENCY

Idiocy

Mongolian Imbecility

Imbecility

Moron (*High grade Feeble-minded*)

The feeble-minded can be divided into three groups (1) Idiots with a mental age of less than three years; (2) Imbeciles with a mental age between three and seven years; (3) Morons with a mental age between seven and eleven years. The moron group has been largely neglected in Canada and has contributed greatly to criminality, vice and pauperism. ——— *The Canadian National Committee for Mental Hygiene conducts activities to secure better provision for the control of feeblemindedness.*

Poster published by the Canadian National Committee for Mental Hygiene.

Genius: An Inquiry into Its Laws and Consequences, finally wrestled genius away from the abstract ruminations of philosophers, delivering it abruptly into the laboratories of late nineteenth-century science. It also, not coincidentally, secured for Galton a place in history as "a Victorian genius."[11]

A prolific and ever-curious pioneer, Galton remained committed to the idea that human variation, including variation of intelligence and disposition, was determined by principles of heredity. He continued for decades to devise new methods for the measurement of human traits, new statistical techniques for the description and interpretation of his findings and new frontiers for the application of this knowledge. In 1883, Galton coined the word *eugenics* to denote "scientific endeavours to increase the proportion of persons with better than average genetic endowment through selective mating of marriage partners."[12]

Thus genius was launched on a course as tumultuous as that of Darwin's HMS *Beagle*.

Galton conceived of an epic battle between genius and eminence on the one hand, and mediocrity, ignorance, and moral deterioration on the other. The victor's prize would be civilization itself. When his ideas crossed the Atlantic, they found fertile soil in the social and economic upheavals of early twentieth-century America. Generations following the Civil War had seen the effects of rapid industrialization, massive migrations to cities, the emergence of militant labor unions, peaking immigration, and a series of economic depressions. Poverty, homelessness, bankruptcy, and crime were on the rise, charitable and religious interventions were proving themselves impotent, and the anxiety of the privileged classes was palpable.

> In an era troubled by rapid and seemingly chaotic change, eugenics offered the prospect of a planned, gradual and smooth transition to a more harmonious future. . . . [E]ugenicists emerged as scientists with a special expertise in the solution of perennial social problems. Eugenics provided what seemed to offer an objective, scientific approach to problems that previously had been cast almost wholly in subjective, humanitarian terms. Whereas charity and state welfare had treated only symptoms, eugenics promised to attack social problems at their roots.[13]

Charles Darwin's explanations of evolution and Francis Galton's proposals for "prudential restraints on marriage" quickly became part of the modern narrative in North American spheres of influence and scholarship. Within those spheres, the strongest endorsements came from some of the most admirable figures in contemporary history.

Oliver Wendell Holmes Jr. was one such figure. Born in Boston in 1841, before the commotions of Darwin evolutionary theory, his privileged roots would bear up well to Galton's pedigree of eminence. His father was a physician, lecturer, and poet of great distinction, and although Holmes Junior pursued a different path, it was no less illustrious. He fought bravely for the abolition of slavery during the American Civil War, studied and later taught law at Harvard, and pursued an impressive career that culminated in nearly thirty years of service as an associate justice of the Supreme Court of the United States. A beacon of justice, vision, and moral courage and a legendary figure in

American public life, he was once affirmed as "the greatest judge of the English-speaking world."[14]

As Holmes was rising to prominence as a legal scholar and jurist, the science of hereditary genius was slowly but surely penetrating American social policy. Infused with all of the urgencies of the era, genius was taking on a distinctly moral quality. A rising crescendo of voices, emanating from universities, laboratories, and legislatures across the continent, chimed a cautionary tale: *We shall be made better by the pursuit of genius, but we must act boldly or be overtaken by its antagonist, feeblemindedness.*

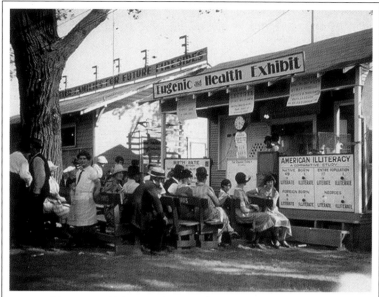

Eugenic and health exhibit at a U.S state fair, 1920s.

Feeblemindedness, like its antithesis genius, was considered measurable and heritable. In order to prevent its spread into future generations, the reproductive proclivities of feebleminded persons would be regulated. Institutions for custodial supervision and confinement were populated on a massive scale. In an ever-increasing fervor to "extinguish the line" of feeblemindedness, practices of containment and sterilization were legally mandated in both Canada and the United States. Estimates indicate that over sixty-five thousand persons were sterilized in thirty-three U.S. states under compulsory sterilization programs.[15] Across the border in Canada, the Alberta Eugenics Board mandated to eliminate "multiplication of the evil by transmission of . . . disability to progeny," approved nearly five thousand cases for sterilization between 1928 and 1972.[16]

While the greatest minds and moral leaders of the early twentieth century championed the cause of eugenics, everyday citizens were simultaneously charmed by the siren call of genius. State fairs across the United States during the 1920s featured "Fitter Families for Future Firesides" competitions, where those with ambitions for genius volunteered for extensive psychometric, psychiatric, and physical examination by judging doctors. Winners would receive bronze medals inscribed with the biblical verse, "Yea, I have a goodly heritage." Blending the nostalgia of rural life with the promise of future prosperity, the Fitter Families campaign bound citizens together in a shared enterprise of propagating genius and its "high-grade" kindred.

There would be many, many castaways in this epic journey of "progress." Carrie Buck was one. Born in 1906, just one year before the passage of America's first eugenic sterilization law, Carrie's pedigree did not meet the Fitter Families grade. Her mother Emma had been committed to the Virginia Colony for the Epileptic and the Feeble-Minded on the basis of her "immorality, prostitution, and having syphilis." When Carrie gave birth to an out-of-wedlock child at the age of seventeen as the result of what is today understood as rape, her own fate was sealed. She was committed to the same institution as her mother, on the grounds of her inheritance of "feeblemindedness, incorrigible behavior and promiscuity." There, consistent with laws on the books in many states and provincial jurisdictions, she would be sterilized without her consent.

Confident that Carrie Buck's circumstances would make for an ideal test case, state authorities named Carrie as the plaintiff in a constitutional challenge to the law of com-

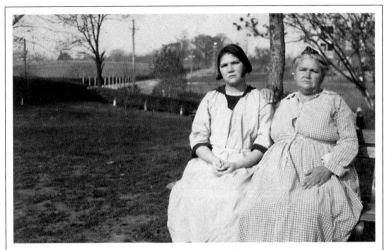
Carrie and Emma Buck, 1924.

pulsory sterilization. At trial, the superintendent of the institution, Dr. Albert Priddy, testified that Carrie and other members of her family belonged to "the shiftless, ignorant, and worthless class of anti-social whites of the South."[17]

On appeal to the Supreme Court, the eminent Justice Oliver Wendell Holmes Jr. and eight of his learned peers solemnly heard and considered legal argument for and against sterilization. Finding that Carrie Buck was "the probable potential parent of socially inadequate offspring, likewise afflicted," the court decided that Virginia's Sterilization Act did not violate the U.S. Constitution, thereby sanctioning her sterilization.[18] In a brief one-thousand-word decision delivered just ten days after the hearing, Justice Holmes, writing for an eight-to-one majority, conclude

> It is better for all the world, if instead of waiting to execute degenerate offspring for crime, or to let them starve for their imbecility, society can prevent those who are manifestly unfit from continuing their kind. The principle that sustains compulsory vaccination is broad enough to cover cutting the Fallopian tubes. Three generations of imbeciles are enough.[19]

Holmes was not alone. Embracing the rhetoric and fervor of a crusade to extinguish the line of feeblemindedness were men and women of such stature as Woodrow Wilson, Theodore Roosevelt, Alexander Graham Bell, Clarence Darrow, Margaret Sanger, Emily Murphy, Nellie McClung, and Helen Keller. Tommy Douglas, the visionary Canadian champion of social welfare and universal health care, wrote in 1933, "[T]he continued policy of allowing the subnormal family to bring into the world large numbers of individuals to fill our jails and mental institutions, and to live upon charity, is one of consummate folly."[20]

With the spirit of righteous commitment inspired by both noble purpose and urgent peril, leaders of state and shapers of public opinion embraced the ruthless logic of eugenic advance. Intoxicated by a strange cocktail of confidence and dread, humans of the twentieth century had lost their way. From the bunkers of eminence and the garrisons of fitter families, a sheer and simple poison was spread. As Helen Keller asserted: "Our puny sentimentalism has caused us to forget that a human life is sacred only when it may be of some use to itself and to the world."[21]

If genius was inherited, so too was its shadow. It would take more than "puny sentimentalism" to purge ourselves of the inheritance of eugenic proclivity.

Reclamation

"What is genius—but the power of expressing a new individuality?"

—Elizabeth Barrett Browning, letter to Mary Russell Mitford, January 14, 1843

We see things differently now. We hold modern views, and the language in which we do commerce with those views tricks us into thinking that we have shaped them ourselves. We imagine ourselves unencumbered by the superstitions of the ancients, by the inhibitions of the unenlightened, by the enthusiasms of those for whom the world was new and uncharted. The words that we utter today feel native and known. We choose them with as much care as the moment warrants, and dutiful servants that they are, we trust them to do our bidding. Our speech is clear. A genius is a genius, except in the colloquial inversion.

But this cannot be so. A word may be estranged from its origins, but genius cannot be sounded without at least some faint echo of the alliances and antagonisms of its past. Meanings may go dormant, and words may fall from active use, but what is on the record for genius is a map of sense and connotation that extends both back and forward through immense ideological shifts. A deep and mysterious riddle for scholars and philosophers in one era, a clear and steadfast benchmark for scientists and bureaucrats in another. A divine and ubiquitous presence in one era, a rare and envied possession in another. Sacred in one era, profane in another.

Yet something more than chronology is at work here. It is not so simple as a pendulum moving back and forth between extremes, although there is surely a comfort that lures the mind to rest in such binary pairing.

Edward Sapir, the influential linguist and anthropologist, challenged the notion that somehow when civilization took its first breath, humankind busied itself with the task of inventing vocabulary to describe the world and our experience. Instead, Sapir taught that the "real world" is built from language, and that we "see and hear very largely as we do because the language habits of our community predispose certain choices of interpretation."[22]

We have not defined genius. Instead, our pursuit of genius has defined us. At every crossroad in our evolution as moral and social beings, genius has been present. It remains present in passionate debate about whether or not the acclaims of genius are deserved, by whom, for what, and at what cost. Similar to notions like "security" and "progress," the terrain of "genius" is perennially contested. In those debates and contestations, what is revealed is not the "fact" of genius, but instead two core aspects of its character:

First, genius is expressive. This is a matter not merely of form, but of essence. Much as we may talk about it abstractly, genius must speak to be heard, must perform to be seen, must act to be known. "Latent genius" is as much an oxymoron as "latent generosity" or "latent fairness."

Second, genius is relational. We prize genius when we behold it in others, and we yearn for others to behold some genius in ourselves. In the beholding, genius is shared. In isolation, genius vanishes. Like "justice" and "community," genius is thus valued for the generosity of its yield, not for what is held by one,

but for what is afforded to many. From these core characteristics, each new generation interprets genius in ways that reveal and express our deepest partialities and dispositions. We cannot willfully erase its standing as the shimmering summit of human aspiration, any more than we can skim away the layers of its dishonor. But we can attune our own capacities to recognize genius so that it is no longer seen in the cruelty of human parsing, but instead in what Elaine Scarry calls "a more capacious regard for the world."[23]

There is, by way of shining example, an insistent genius in the pages of this book.

The genius that speaks out from these photographs is the genius of common cause, the genius of communities governed not by orthodoxy but by small heresies of intention and invention. These are communities that erupt into flourishing, communities that rise on pillars of respect and connection. The photographs in this volume chronicle a genius of the everyday, a genius that has returned to its roots, to an affirmation of human singularity and liveliness. With breathtaking sensibility, Vincenzo Pietropaolo's photographs offer up the genius of "coming into being."

We see here the possibilities for a genius stripped of hubris and cupidity. What the photographer has noticed in largely unseen worlds of work, communion, and play serves now as entry point for a radically different project of human betterment, a twenty-first-century project of hospitality and contribution.

To speak of this work broadly, as a collection of images of people with disabilities living in community, might miss the point altogether. There is no single composite or template for the singular genius of inclusion. As Elaine Scarry explains, generic terms such as "living" or "community" exclude all that takes place "only in the *particular*."[24] Each of the subjects who greet us from the pages of this book is distinct and individual, not some proxy for similar lives in similar communities. Here we behold a truly radical originality, a fresh embrace that welcomes those who for centuries have been excluded from the most central and basic of human relations. On each page, we glimpse lives shaped not by some callous grammar of utility and waste, but instead by a steadfast brilliance of *making way* for all.

There is no formula, neither for these photographs nor for the politics of inclusion that make sense of them. What unfolds from this body of work is a cascade of detail and moment. A musical phrase is mirrored in a man's pensive look. A mother's hands reach for a steaming kettle. A retail worker surveys a well-stocked rack. A boy gathers pebbles. Family members raise their glasses in a celebratory toast. Two young friends share a sidewalk and a story. Coworkers engross themselves in the unspoken familiarity of shared endeavor. Exquisite, yet ordinary moments. Small and simple gestures that pinpoint large and weighty truths.

From each image we can trace a common path back through the dark history of the eugenic era, and an uncertain path forward toward a precarious future. At the same moment as we acknowledge the arresting presence of the individuals, families, and friends who are the subjects of this work, we are wrenched back to recall Justice Holmes's dire warning. Are these the "catastrophes" that people of our own temperament and loyalty to law and progress just eighty years ago struggled to fend off? Had their ambitions been more fully realized, none of these photos would exist. Nor would their subjects.

Like the coffee table upon which a book like this is placed, just outside the frame for each image stands today's Big Science, promising the detection of genetic and chromosomal difference, bearing down upon our reverie, pledging the means to prevent lives

that might otherwise look like these, and prompting us to ask, "Which master does this enterprise serve?" Might Pietropaolo's images record not merely fleeting moments, but a fleeting *human kind*, final gestures recorded as elegiac tribute en route to a world where genetic endowments are selected before birth? Will our striving for genius be expressed in the compulsion to extinguish lines? Or will we instead pursue a genius of human connection?

In ways both instrumental and symbolic, that choice is ours to make.

As we seek our own place in this body of work, we can expect a range of responses. We may feel upbraided for our own stubborn refusals to see a grace, humanity, and promise now so plainly evident. We may feel disoriented from a sudden jettison of catechisms of futility, desolation, and loss. We may feel beckoned toward some larger imagining of social life, some new calibration of human dignity and worth. We may feel emboldened to pursue a mindful ignorance of old rules that separate, denigrate, and discard.

In this sudden torrent of possibility, a photographer invites us to relinquish "our imaginary position as the center."[25] Pietropaolo's images serve as a kind of overture to an experience Iris Murdoch has described as "unselfing"—the falling away of a cluster of feelings that normally promote the self, instead giving over to the service of something or someone else. As Scarry writes, "At moments when we believe we are conducting ourselves with equality, we are usually instead conducting ourselves as the central figure in our own private story. . . . When we feel ourselves to be [decentered] . . . , we are probably more closely approaching a state of equality."[26]

Decentering is no small feat. To knock us out of small and selfish orbit, to disrupt the supremacy of "cognitive acceleration," to unsettle the binary of what is "ordinary" and what is "special," requires a force no less than genius. In the present instance, this power lies neither in the photographs nor in the directing mind, although both are exemplary. The transformative power of this work stems from the quiet genius that animates these images—the simple majesty of *lives lived well, with disability*.

May these images inspire not the warm wash of a distant admiration, but the clear resolve of an active and urgent emulation.

NOTES

1. Online index of Greek and Roman mythology, http://www.mythindex.com/roman-mythology/G/Genius.html (accessed October 2007).
2. "Genius," *Encyclopædia Britannica Online*, http://www.britannica.com/EBchecked/topic/229161/genius (accessed April 13, 2009); and Jane Nitzsche, *The Genius Figure in Antiquity and the Middle Ages* (New York: Columbia University Press, 1975).
3. Shel Kimen, "The Power of Genius," *Concepts of Culture*, Spring 2003, http://www.klever.org/wrdz/world/genius.html (accessed April 26, 2009).
4. Ibid.
5. Martin Gammon, "Exemplary Originality: Kant on Genius and Imitation," *Journal of the History of Philosophy* 35 (October 4, 1997), 590. (Citing Immanuel Kant, *Critique of Judgement*.)
6. Ibid., 568. (Citing G. Hamann, *Sokratische Denkzeiirdigkeiten* [Amsterdam, 1759], 74; *Socratic Memorabilia*, trans. James C. O'Flaherty [Baltimore: Johns Hopkins University Press, 1967], 169).
7. "Sir Francis Galton," *Encyclopædia Britannica Online*, http://www.britannica.com/EBchecked/topic/224628/Sir-Francis-Galton (accessed April 14, 2009).
8. Alfred Wallace, "Hereditary Genius, a Review," *Nature*, March 17, 1870, 502.
9. J. A. Plucker, ed., "Human Intelligence: Historical Influences, Current Controversies, Teaching Resources" (2003), http://www.indiana.edu/~intell (accessed April 15, 2009).
10. Wallace, "Hereditary Genius," 502.
11. D. W. Forrest, *Francis Galton: The Life and Work of a Victorian Genius*, (London: P. Elek, 1974).
12. "Sir Francis Galton," *Encyclopædia Britannica Online*.

13. Allen Garland, "Social Origins of Eugenics," Dolan DNA Learning Center, Cold Spring Harbor Laboratory, http://www.eugenicsarchive.org/html/eugenics/essay_1_fs.html (accessed April 15, 2009).

14. "Washington Holds Bright Memories of Justice Holmes's Long and Useful Life," *New York Times*, March 6, 1935, http://www.nytimes.com/learning/general/onthisday/bday/0308.html (accessed April 14, 2009).

15. Daniel Kevles, *In the Name of Eugenics: Genetics and the Uses of Human Heredity* (New York: Knopf, 1985).

16. Gerald Robertson, "Eugenics in Historica," in *The Canadian Encyclopedia*, 2006, http://www.canadianency-clopedia.ca/PrinterFriendly.cfm?Params=A1ARTA0010721 (accessed April 15, 2009).

17. David Micklos, "None Without Hope: *Buck v. Bell* at 75," Dolan DNA Learning Center, Cold Spring Harbor Laboratory, http://karmak.org/archive/2004/06/buckvbell.html (accessed April 14, 2009).

18. *Buck v. Bell*, 274 U.S. 200, 47 S.Ct. 584, 71 L.Ed. 1000 (1927), http://www.law.cornell.edu/supct/html/historics/USSC_CR_0274_0200_ZO.html (accessed April 14, 2009).

19. Ibid.

20. Thomas Douglas, "The Problem of the Subnormal Family," unpublished manuscript, March 17, 1933, http://www.katewerk.com/tommy/ (accessed May 14, 2009).

21. Martin Pernick, *The Black Stork: Eugenics and the Death of "Defective" Babies in American Medicine and Motion Pictures since 1915* (New York: Oxford University Press, 1996), 92.

22. Edward Sapir, "The Status of Linguistics as a Science," in *Culture, Language and Personality*, ed. D. G. Mandelbaum (Berkeley: University of California Press, 1958), 69.

23. Elaine Scarry, *On Beauty and Being Just* (Princeton, N.J.: Princeton University Press, 1999).

24. Ibid.

25. Ibid.

26. Ibid.

A Journey in Photographs and Words

VINCENZO PIETROPAOLO

Life can be circuitous. As I write these words, having just traveled across Canada making the pictures in this book, I realize that in a way the project had its genesis on September 26, 1975. As a young, aspiring photographer, on that evening I attended a lecture at Ryerson University in Toronto by the legendary photographer and humanist, W. Eugene Smith. I had secretly "defined" him as my mentor, and looking back across the years, I could not have known how deeply the evening would affect me.

It was a large auditorium, and I sat in one of the front rows. The way I remember it, Mr. Smith spoke not only about his brilliant career (as one of the world's most respected photojournalists), but also about ethics and photography, about the responsibility of the photographer to the people that he photographs, about the power of the camera, about truth, subjectivity, and objectivity. It was an overflow crowd, and the diminutive Mr. Smith held his audience enraptured. He showed black and white slides from his photo essays, spoke movingly about his experiences in World War II, and toward the end he started to show his work about Minamata, a small town in Japan whose main food source of local fish had been contaminated by mercury pollution, with devastatingly harmful effects on the health of the local population. When he came to one particular slide, he stopped for a long time, and he stared at it in silence. It was a picture of a woman with a child in a traditional Japanese bathing tub. The mother was holding the child in her arms with pride and great tenderness; both seemed to be rising out of the dark water into the light, but the child looked almost lifeless, her limbs stiff and her expression vacant. The picture is called "Tomoko and Mother in the Bath." Tomoko Uemura was born with multiple physical and intellectual disabilities due to the effects from mercury that her mother had unknowingly ingested by eating the contaminated fish while pregnant. Tomoko suffered from the effects of what came to be known as Minamata disease, and in the picture she looked unusually tiny, though she was already a young woman of eighteen.[1]

Mr. Smith continued to stare at the slide for a long, long time; the crowd in the darkened room became perceptibly uncomfortable. Eventually he broke the awkward silence, and in a trembling voice said, "Tomoko, I failed you." By the light of the lectern beside him, I could see a tear glistening on his cheek. Mr. Smith went on to the next slide, but later he was asked what he meant by his remark. He replied that he had felt uneasy in taking the picture, as if he were transgressing some ethical boundaries, and only did so with the mother's consent. But he felt that the picture could not possibly convey the depth of suffering that Tomoko must have been going through in her life, and that therefore it was a "failure." Yet the picture is acknowledged by historians and critics as one of the greatest ever made in the history of photography. The endless love that can be seen in the mother's expression as she holds her daughter who seemingly cannot respond, coupled with the classic composition and dramatic effects of the chiaroscuro

lighting, have made the picture into a metaphor of humanity against the adversity of tragedy. It has often been referred to as the modern Pietà, as its immense power continues to move the human spirit.

My memory of that evening has remained indelibly marked in my mind, and I have since looked at the image many times in books. As I traveled making pictures for this book and met many people with varying disabilities, the image of Tomoko and her mother became ever more vivid in my mind with each passing day. Sometimes it almost seemed as if it was silently following me, as a reminder of the ethical considerations that Eugene Smith spoke about so eloquently on that evening. This book then is as much a gesture to W. Eugene Smith's legacy as homage to the people who shared their lives with me through my camera.

When I began to work on *Invisible No More*, I truly had no idea of the intense involvement in people's lives it would entail. To make the pictures, collect interviews, and simply spend time with people informally, I visited about forty towns, cities, and villages. I broke bread—sometimes literally, sometimes spiritually—with over one hundred families, and individuals in their homes, workplaces, parks, schools, shopping centers, and places of worship. I traveled to every province and territory in Canada, and to the United States on one occasion. From sea-to-sea-to-sea, as we like to say in this country. I stopped in "remote" communities with names like Cap-Pelé, New Brunswick; Rankin Inlet, Nunavut; Powell River, British Columbia; Marystown, Newfoundland and Labrador; Summerside, Prince Edward Island; and larger cities like Edmonton, Saskatoon, Winnipeg, Montreal, Toronto, and Halifax.

But it was much more than a journey across the land. It was a journey through a terrifyingly beautiful human landscape, a sea of humanity known as the disability community. It was not without considerable trepidation that I undertook the journey for fear of failing in this delicate task that required intimate involvement in people's lives. At first it was disarming how warm and affectionate everyone was toward me, how easily they welcomed a total stranger into their lives. Everyone, it seemed, felt a need to tell his or her story, or to tell it on behalf of those who didn't have the ability to speak by themselves or the power of articulation of their own. Everyone needed to have someone listen.

Like many Canadians, I had become accustomed to not seeing, not hearing about, not being personally aware of many people with intellectual disabilities. They have been a largely invisible part of the population, hidden inside the impenetrable walls of infamous institutions. When not actually locked up, they were rendered invisible from society's prying eyes, cloistered inside their own homes, burdened with the stigma of shame for having been born, for existing. The more out of sight they were, the less one had to carry the weight of thinking about them, the less need to make adjustments to the routine patterns of living, the less need to reconsider prejudicial and criminal attitudes, the less need to be bothered with human rights or social justice. The more involved I became in the work, the more self-revealing it was. I had previously known many people with intellectual disabilities—neighbors, extended family, workplace mates, children of friends—but I had not considered them worthy of too much attention, and had conveniently put them aside in my mind.

In the annals of human rights, community after community has struggled for the inviolable rights that every human being is born with. A quick glance at history reveals the social movements and revolutions that have been fomented, incited, and fought—to establish democracies, to abolish slavery, to recognize the rights of women and the rights of children, to recognize gender and sexual equality, to recognize the rights of

immigrants, the rights of workers to organize, the right of an accused person to a fair trial, the presumption of innocence before guilt, the rights of people of First Nations, the rights of people to come together as nations through self-determination. But through the ages, we have mostly forgotten about the most vulnerable members in society, both in life and death, for we have even buried some people with intellectual disabilities in unmarked graves, taking away their right to an identity forever. As if they had never existed on this planet.

. . .

Photography is one of the most universal languages; as a visual medium it has the inherent power to traverse the frontiers imposed by spoken and written language. It is accessible universally and has the power to provoke, to move the spirit and to penetrate across cultures. When combined with words, the two narratives become fused much like one braid, and each of the intertwining strands impacts powerfully upon the perception of the other by the viewer/reader. John Berger, writing about photography and words, stated that "the photograph begs for an interpretation, and the words usually supply it. The photograph, irrefutable as evidence but weak in meaning, is given a meaning by the words. And the words . . . are given specific authenticity by the irrefutability of the photograph."[2]

Photographic portraiture and documentation are challenging enough in ordinary circumstances, but especially so in the ambiguous and undefined world of disability. "The portrait of a person," said Paul Strand, one of the great luminaries of photography, "is one of the most difficult things to do, because in order to do it, it means you must almost bring the presence of the person photographed to other people in such a way that they don't have to know that person personally in any way, but they still are confronted with a human being that they won't forget, the image of whom they will never forget. That's a portrait."[3] My objective was a modest one: to produce a record of the encounters that I made, without preconditions, in a world that would be new for me. I present these pictures and words as a collection of moments in time which I was invited to share, but I am hopeful that these rather ordinary moments will resonate with the humanity of the people who graced my camera, whose lives are nothing if not extraordinary, and whose presence will endure in these pages so that in time they might constitute a collective portrait.

My camera is my constant companion, and with it I strive to gain people's trust and be present in their lives, even if briefly, without resorting to artificial conditions. In my encounters, I have sought to avoid potentially exploitive moments that could easily lend themselves to being interpreted as grotesque or picturesque; nor have I been keen to record faces with blank stares, full of suffering and emptiness that are typical of images associated with residents of mental institutions. Life does not consist solely of high points of human emotion in chiaroscuro, but of a continuous flow of ordinariness, and such moments that are the patina of quotidian living: like having a simple meal, listening to music, being lost in a book, working a conveyor belt, hugging a pet, chatting with friends, absorbed in solitude. The challenge is to photograph from within, in collaborative synchrony with the people who might be subjects, with as little intrusion as possible, without causing unnatural changes. No words have perhaps expressed more eloquently the importance of respecting the naturalness of the moment and portraying it in its purity than the words penned by Francis Bacon in Elizabethan England, which in turn Dorothea Lange, one of the greatest documentary photographers of the twentieth century, adopted as a sort of credo, pinning them even to her

darkroom: "The contemplation of things as they are, without substitution or imposture, without error or confusion, is in itself a nobler thing than a whole harvest of invention."[4]

But the camera is not the unbiased witness that it has been naively held to be in popular culture. It is a powerful storytelling tool; only as objective as the storyteller who is using it . . . and I never met a storyteller who claimed to be objective. Its great power lies in its visceral qualities, in the immediacy of effect that a photograph has on the human psyche, and its capacity to speak to the heart and to the mind at the same time. If it is the right moment, a photograph can be evocative and move people. But who is to decide the right moment, whose truth shall prevail? With such power, the photographer is charged with the grave responsibility of respecting the dignity of the persons who stand in front of his camera. This is doubly so if they cannot verbalize their feelings. The question of ethics is an exacting burden.

This has been a transformative experience for me on many levels. I have struggled—I am struggling—with the word *disability*. Often I did not sense a disability that warranted more explicit identification than some of my own shortcomings. We all have disabilities; it is often a question of who decides what a disability is and what limitations are subsequently imposed. It is a question of power. If I have reached a conclusion, then, it is an elementary one: disability is a concept forged by "us" for "them." We, the controlling portion of society, are the exclusionary ones, and they, the vulnerable and weak in our eyes, are the inclusive ones.

As I look at the pictures, I think back to the moments when I made them, those moments when everything seemed to come together. When I photographed workers at conveyor belts in the Maritimes, cutting and packaging fish, I could not tell who had disabilities and who did not. When I first met Van, a fifty-seven-year-old man with Down syndrome, he smiled, rushed over to me with open arms, and said, "Hi buddy." And I knew that when Maurice, a blind and mute autistic eight-year-old, brushed his head on my stomach, he was trusting me. In the moments that I spent with Alexis, or André, or Rebecca, or the young Jaina, the image of Tomoko from Minamata would flash through my mind. I don't know what my pictures would mean to them, or to the people close to them. For my part, I offer these photographs and words as a gesture of solidarity in their struggle for social justice, which is also *our* struggle for humanity and humility.

NOTES

1. W. Eugene Smith and Aileen M. Smith, *Minamata* (An Alskog-Sensorium Book. New York: Holt, Rinehart and Winston, 1975).
2. John Berger and Jean Mohr, *Another Way of Telling* (New York: Vintage International, Random House, 1995), 92.
3. John Walker, *Strand: Under the Dark Cloth* (Documentary Film, 1989).
4. Milton Meltzer, *Dorothea Lange: A Photographer's Life* (New York: Farrar Strauss Giroux, 1985), 79.

Photographer/Author's Note to the Reader

The photographs and texts that follow are intended as two parallel narratives that tell stories about inclusion. The texts are based on conversations and encounters that I engaged in during the making of the images. The photographs capture a fleeting moment, a mere fraction of a second that is frozen in time; the texts are more general and relate to feelings and life experiences that may resonate over long periods of time. A text may also relate to several photographs at the same time, and therefore there are fewer texts than images. The photographs do not necessarily relate to the texts that precede or follow them.

My intention in juxtaposing the photographs and texts is to take the reader beyond the specificity of time and place that is depicted and recorded by the photograph. The visual narrative and the written narrative can each be followed on its own, but each will naturally weave in and out of the flow to reinforce the other, as in a braid.

I am hopeful that the overall experience will lead to a transformation of the reader's perception of the lives of people with intellectual disabilities and their struggle for inclusion.

Photographs and Stories

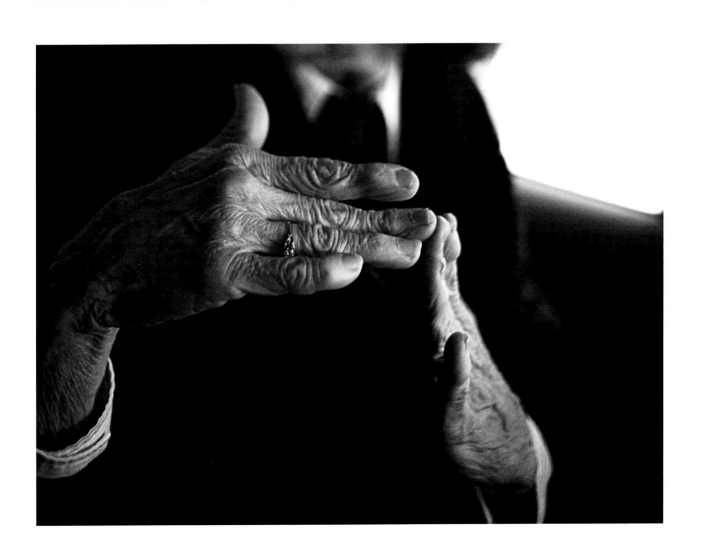

21

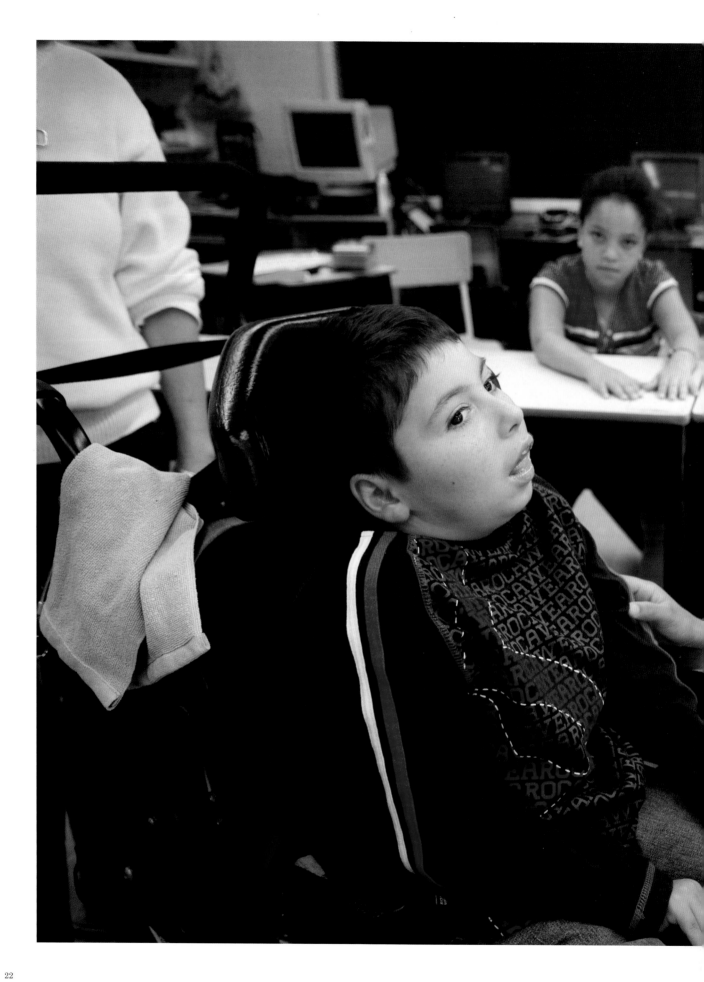

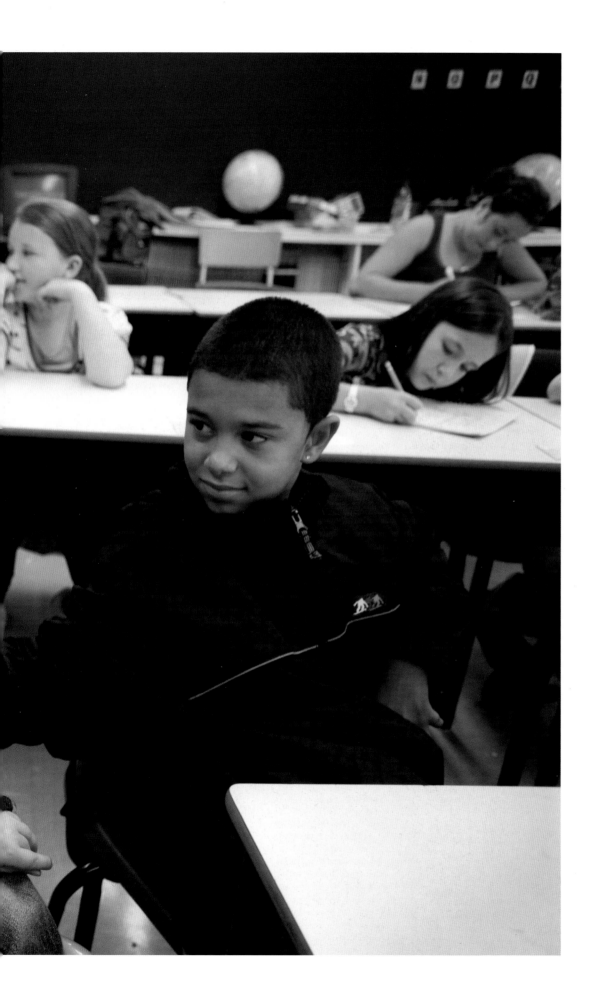

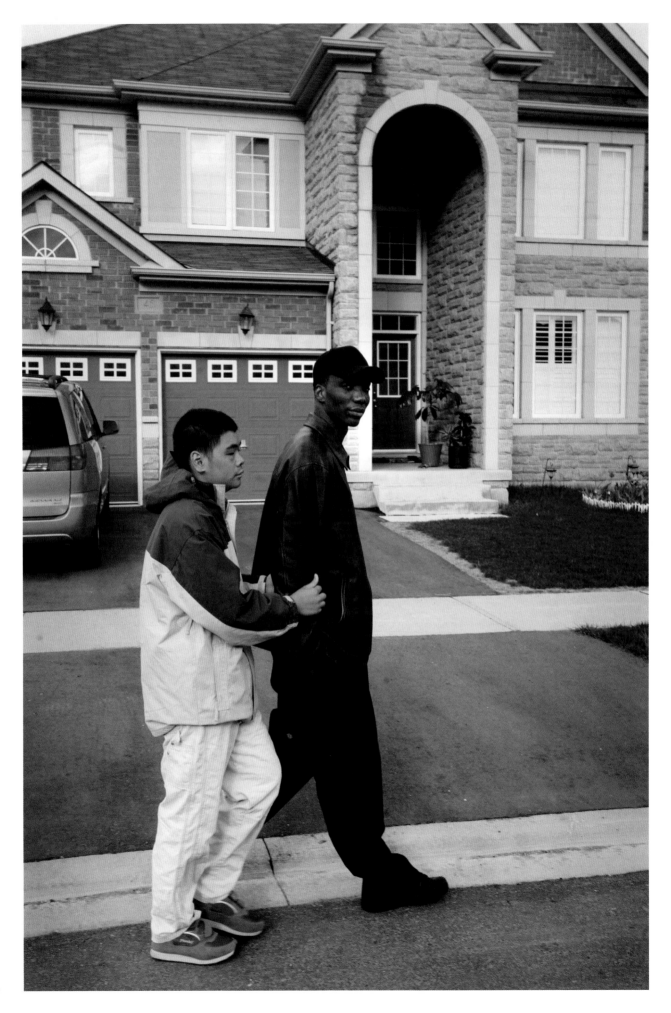

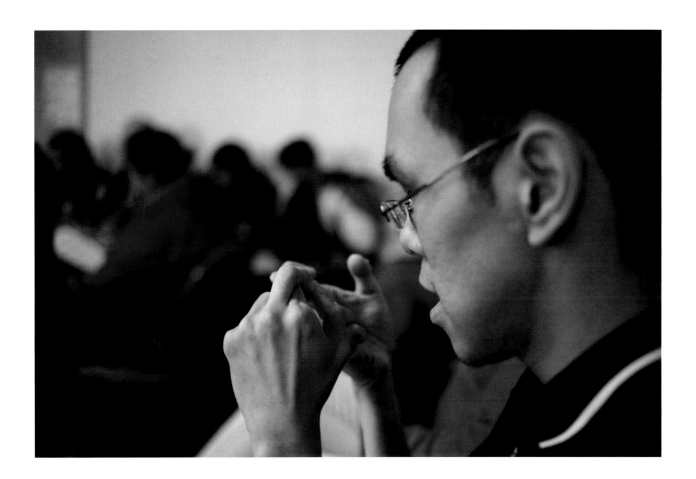

Friendship

The moment I first saw Luc and Olivia standing together on the sidewalk, I knew they must be very close. At ten years of age, they are lifelong friends, and, in a way, they had become friends even before they were born. We went for a walk to a local park, crossing through residential streets lined with stately trees that towered over modest homes in Halifax, Nova Scotia. It was the way that Olivia looked at Luc, the way she always stood by him. Her manner was soft and gentle, but also persuasive and thoughtful beyond her years. Sometimes she held his hand, but only for as long as Luc wanted to. She always had an eye out front for him, looking out for cars and other perils. She knew that in his zeal of walking, her friend would enter a world totally of his own, and would pay scant, if any, attention to traffic and other hazards of the road. In the park they played on the swings, and Luc was exuberant, flying freely into the air; Olivia was more restrained. Later still, on a busy commercial street with convenience shops, restaurants, beauty salons, a hardware store, and the like, Luc vigorously negotiated his way through the thick crowd of Saturday afternoon shoppers. Olivia deftly guided him, so as to avoid getting in the way of people, all the while teaching him—without trying to teach him—how to be respectful of others.

The mothers of these two best friends are also lifelong friends. Anne Louise and Caroline have been inseparable since the age of eight, going to school together, getting married at about the same time, living close together, sharing their joys and tribulations as they raised their families. They even became pregnant with Luc and Olivia, respectively, months apart. Luc was born first, in April. By the month of August, toward the end of her pregnancy, Caroline would often sit with Luc and lay him on her belly, or she would walk around holding him on her belly, and in those moments, she was carrying two children. It seemed as if Olivia was calming him down even then when she was still in the womb. Anne Louise absorbed the scene, and over time it became indelible in her mind, like a photograph that was never taken. Is it because of that physical experience when one was still a fetus and the other already an infant, that Luc and Olivia have such an exceptional bond? Is it a surprise that Olivia is so intuitive to the particular needs of Luc's that are borne out of genetic differences? And if those needs are unique, what is their friendship if not equally unique? In The Prophet, Kahlil Gibran said, "Your friend is your needs answered."

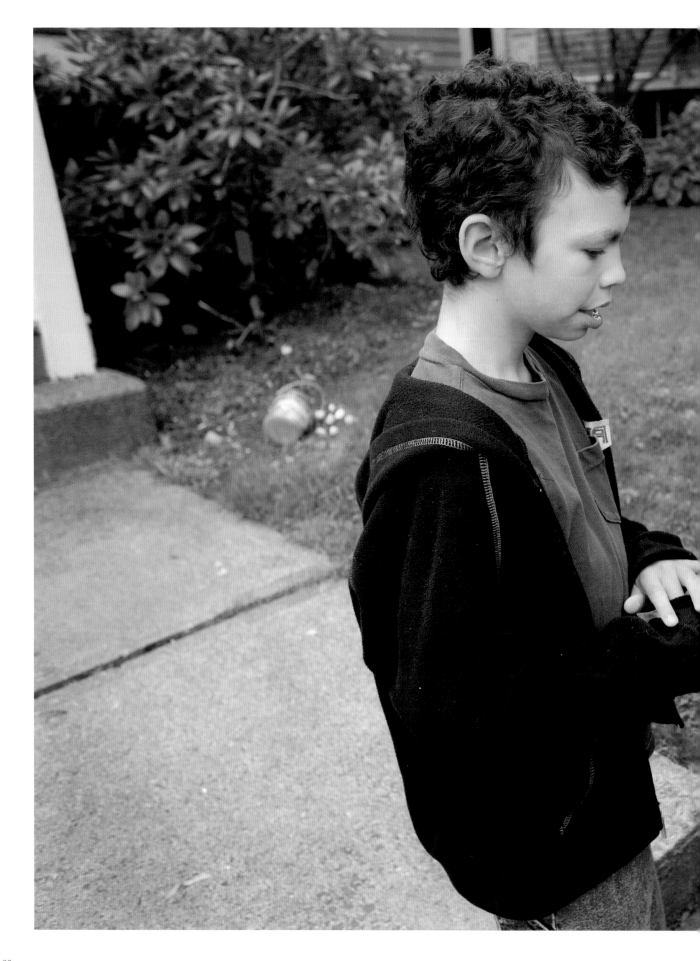

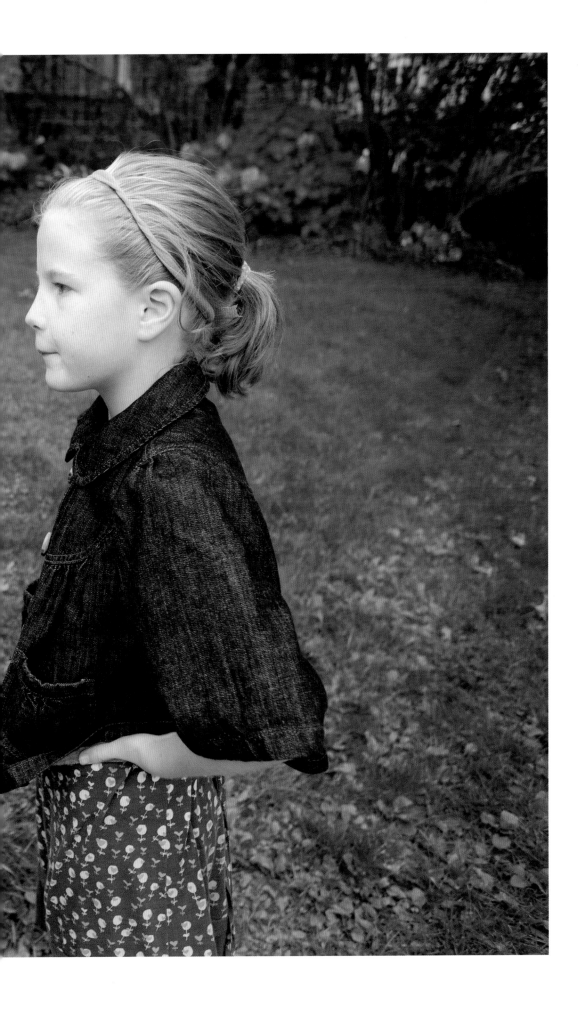

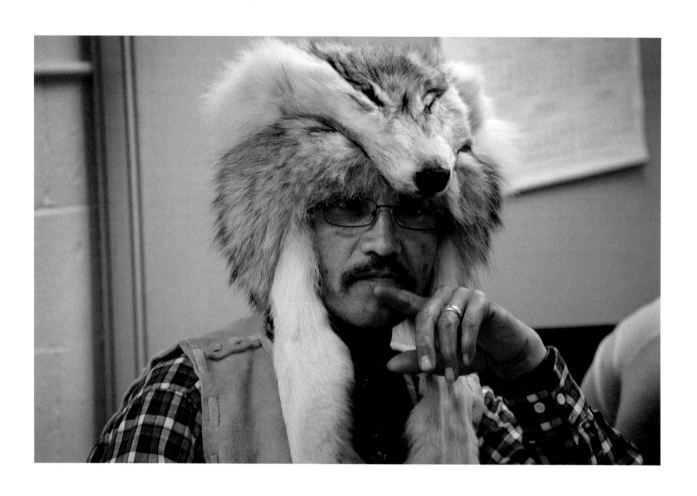

Confidence

Julien goes about his daily tasks quietly, disturbing nothing and no one, barely leaving a trace as he goes about his routine walks in a northern city that he calls home. He treads softy, almost with stealth and trepidation. But he is also determined and resolute, and seeks acceptance in a world that too often ignores those who are quiet, shy, and don't proclaim themselves with boldness. Julien channels his energies differently. His life achievement has been nothing less than the transformation of learning disabilities into creative abilities and artistic accomplishments. He has discovered the healing powers that are inherent in the act of creating aboriginal art and crafts, which he makes from materials harvested from nature. As he stretches a hide on a circular spruce frame for a drum, he creates more than a musical instrument; as he carves a tree branch, he creates more than a sacred animal or bird. With every stretch of the hide and every cut of the carving knife, he affirms his sense of worth.

His masterpiece is a hat that he made from the entire pelt of a timber wolf, including the head. As he carefully dons the trademark garment, his movements are slow and deliberate, intended to achieve a sense of ceremony and ritual. He lifts the furry and warm-looking pelt high above his head, and as he lowers it slowly into position, the scene evokes a self-coronation by a regal prince. He then adjusts it carefully so the animal's snout dangles slightly over his forehead and the thick fur cascades over the rim of his eyeglasses, while the rest of the animal's face comes to rest frontally above the princely head. He deftly places the forefinger of his left hand on his chin, right below his lower lip, and holds it still, creating a formal pose that is strikingly similar to the classic portraits of aristocratic gentry. He stares partially into the distance and partially into the camera lens, inviting me to capture his self-image. The metaphor is complete: by symbolically carrying the wolf on his head, it's as if the supreme confidence of the animal has been transferred to him. As he carries the wolf, so the wolf will carry him.

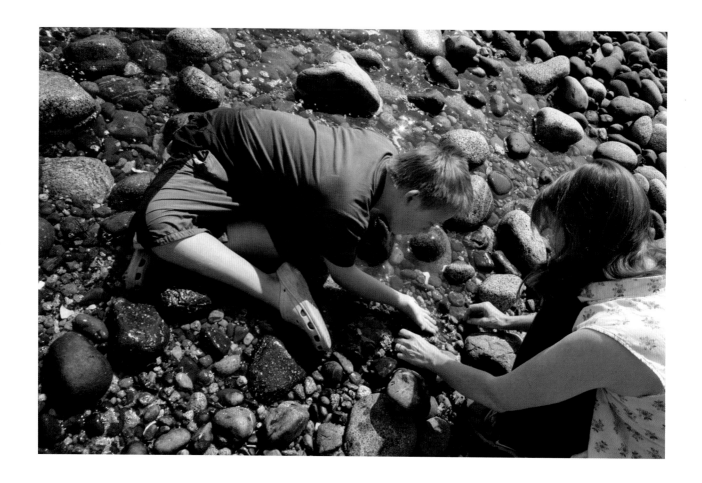

Adoption

Deb chooses her words carefully, trying not to diminish either the sense of contentment nor the intense pain that have marked her spirit, as she tells me the story of how David, her sister's birth child, came into her life. She lives with her family in a small island community off British Columbia, an idyllic place of natural beauty that belies the courage and tenacity that brought them here from the "big city" in the first place. It was their quest to find a less hectic environment in which to raise David, who was born with Down syndrome, but also a place where they could continue to find meaning and grow as a family.

It was a sudden and deliberate decision that Deb and her family made after she received a long-distance call from an official in the Ministry of Child and Family Development. The social worker was crystal clear: they would apprehend David and place him in foster care unless she came to pick him up, 300 miles away, the next day. David was barely five months old, in hospital with pneumonia, and his mother was no longer able to look after him, due to an acute crisis caused by drug addiction, which, ironically, she overcame only two months later and has been drug-free ever since. Deb and her husband, Hal, had already raised three children aged eleven, twelve, and sixteen, but "there was no question, absolutely no question of David coming into our family . . . knowing, too, that we might have him forever." It was a huge adjustment for everyone, and at first there was much joy and laughter at the novelty of having an infant in the family, but as the reality of the baby's special needs and the grind of daily life set in, things became difficult. David started to show behavioral patterns that would later be attributed to autism. Doubt set in, resentment even. Conflict developed between the family members, whose lives had now been profoundly changed by the innocent David.

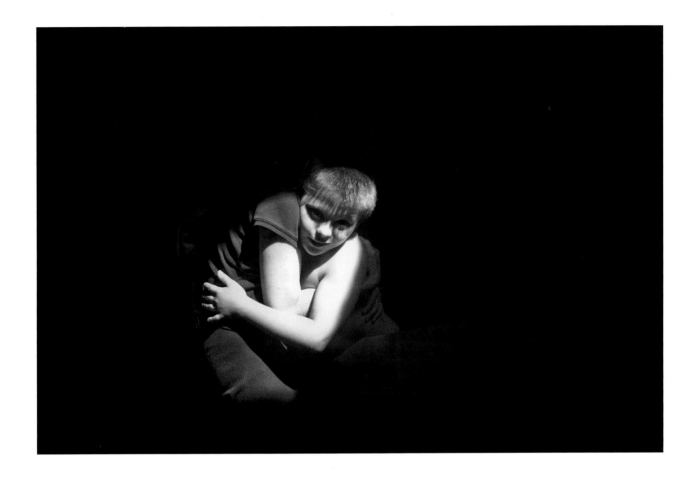

There was a reverse side to the joy that David brought, for as Deb explains, "Never in my life had I been brought to my knees . . . and to the ground in a way that demands that I be honest and real. Until David came I thought I could do anything, I could be an A student, an A mother, I could help the masses, and this one little boy cracked me, tore the façade completely, and for the first time in my life I said *I can't do it.* . . . He overtook everything, and brought me to a place of limitation where you get your strength. He gives me my strength, now, and my concept of faith has been shot to the ground and then transformed."

The moment that David returns home from school with his dad, he leaps into his mother's waiting arms, and a gargantuan charge of energy and joy fills the room, as mother and child seem to be protectively framed by the shafts of golden afternoon light that penetrate through the thick foliage into the kitchen window. This is the place that David has unwittingly brought her to, and while it is not the life that she had wanted, it is a life with simplicity and a clarity of purpose in which she finds ever greater meaning. Moments later David bolts out of the embrace, shakes my hand in acknowledgment, and runs to his room to play music and to dance on his bed. In his wake, he leaves something intangible in the air, waves of something that we can't quite define, as Deb and Hal and I look at each other with pure disbelief at this spurt of energy. The little tornado that just broke away from his mother's clutch has left us at a loss for words. We hear the music that he's dancing to in his bedroom, and we acknowledge as much with our eyes. "Finally," Deb says, "my life is better as a result of David."

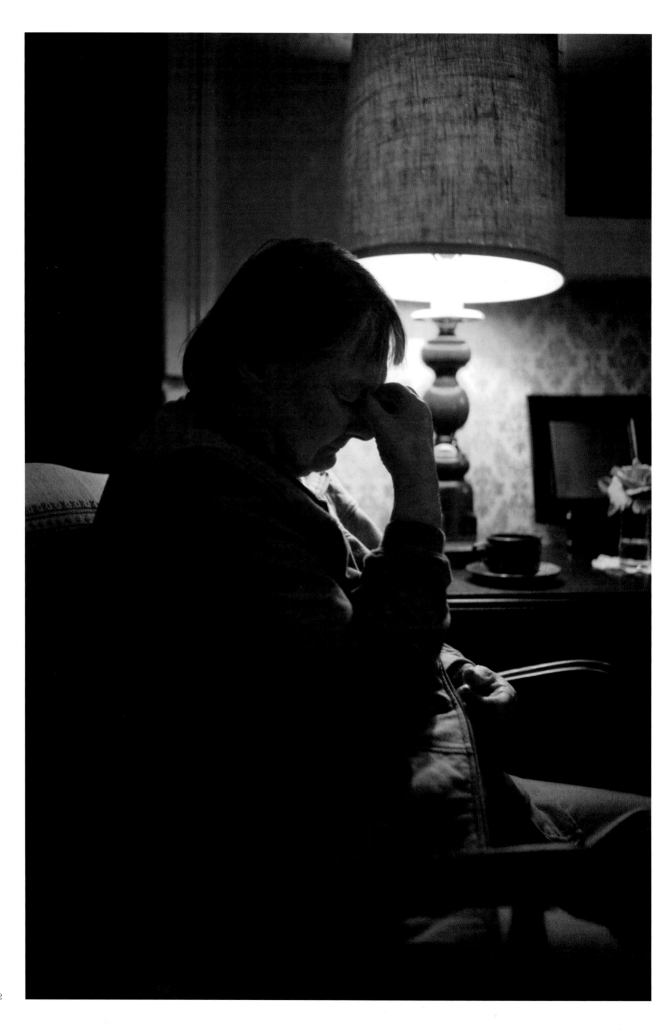

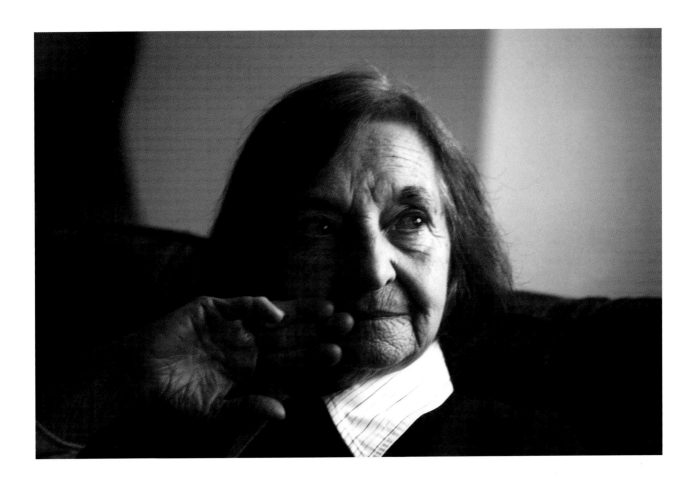

Mothers

My elderly aunt Lisa once said to me, "Mothers are mothers." I wasn't quite sure what she meant by the off-hand and ambiguous remark, but the tone of her voice was definitive and final, like the pounding of a gavel when a judge renders his judgment. The bond between a mother and her child is unshakable; the mother is all-knowing, all-powerful, and, especially, all-loving. In the ongoing struggle for justice and human rights, it is the mothers who have stood out as the true heroes around the world, from the white-kerchiefed grandmothers of Argentina's *desaparecidos* to the Raging Grannies of Canada and Another Mother for Peace in the United States. It is they who have defied conventional wisdom and practices, who have rejected their doctors' advice, challenged their own families, fought with authorities, and unflinchingly believed in their children when others would not or could not. Their first battle was one of self-defense, fighting the prejudice directed against them because they were merely "mothers." But many an expert has learned the hard way to heed the old adage to "never cross somebody's mother." Looking back to the time when people with disabilities were kept away from prying eyes, hidden—or locked up—in institutions, the older generation of mothers were pioneers in human rights and activism. Relentlessly driven, they broke ground. They have now passed on the torch to a new generation of mothers, those who could well be their grandchildren, and whom the fathers now often join in solidarity and action.

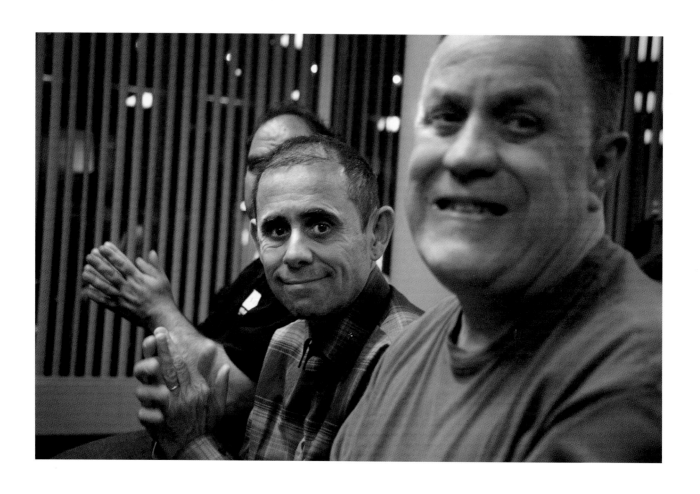

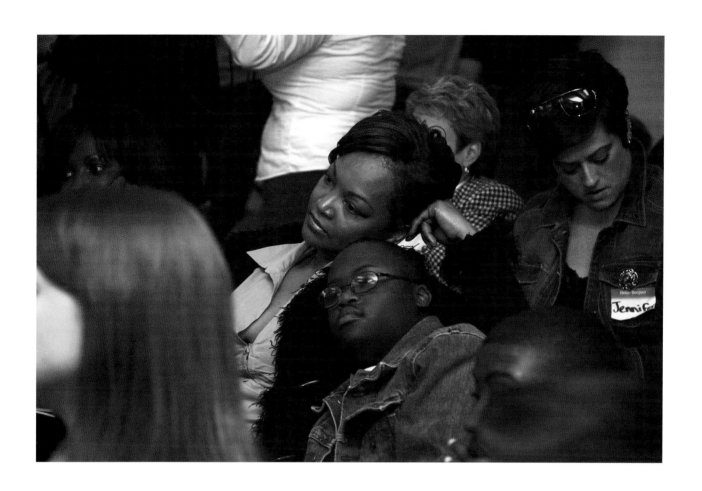

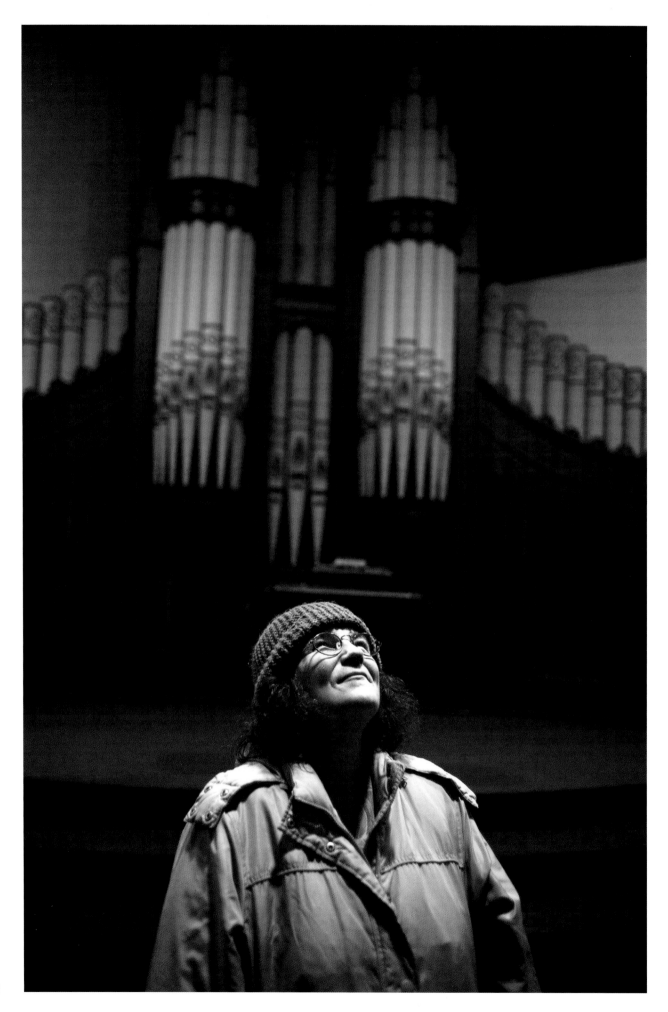

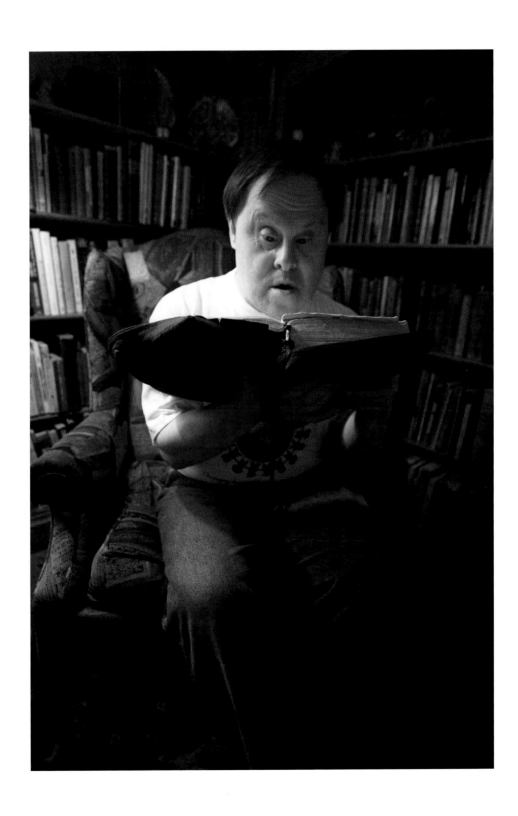

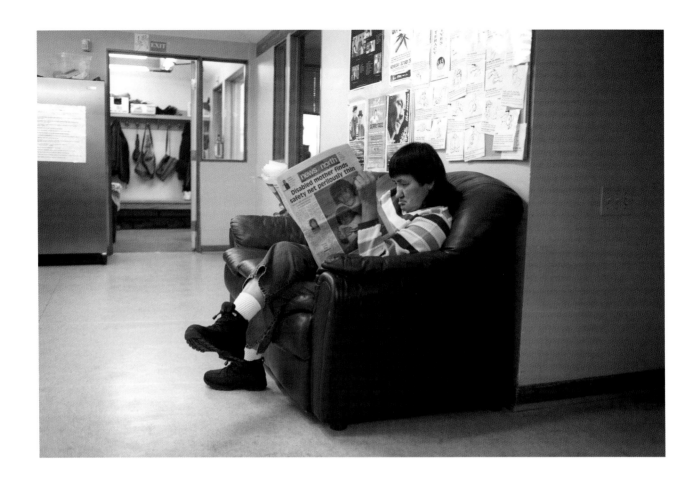

Puppy Love

Rebecca and Jordan are two teenage siblings who have lived in adoptive homes until recently. They are living with the effects of fetal alcohol syndrome. Today they dropped into the FASSY (Fetal Alcohol Spectrum Society of Yukon) center in Whitehorse with a two-month-old puppy. A day earlier they saw that the puppy was being abused: someone was giving it alcohol to drink. They decided to take it away and find a good home for it, because they cannot keep it themselves in their own home. They cradle the puppy in their lap. Sometimes they hold it close to their chest, with pride and tenderness, like two parents holding a child. They know exactly what the puppy needs: to be held and to be loved. They, too, know what it's like to need to be loved. They happen to be sitting under a sign that says "Inclusion" and "Dignity."

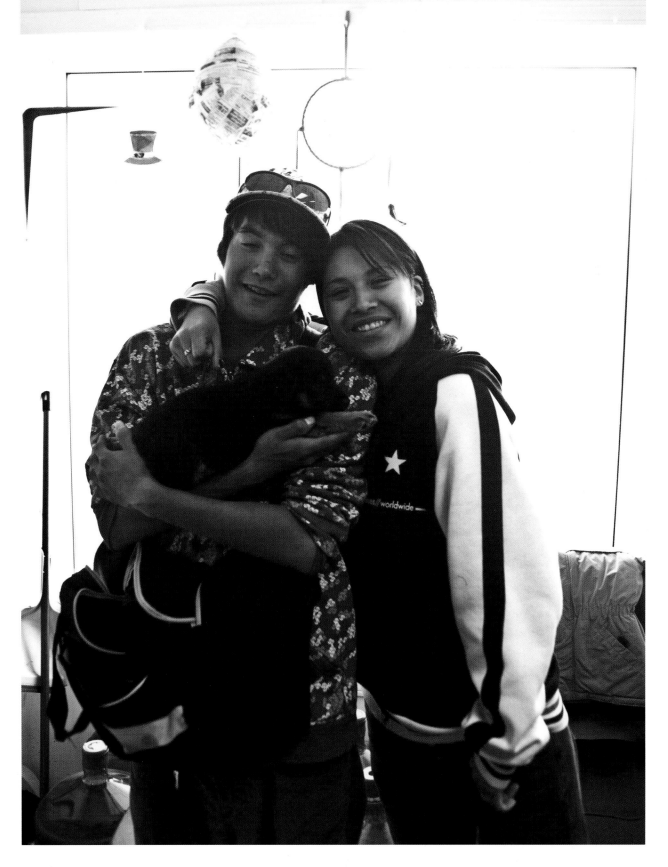

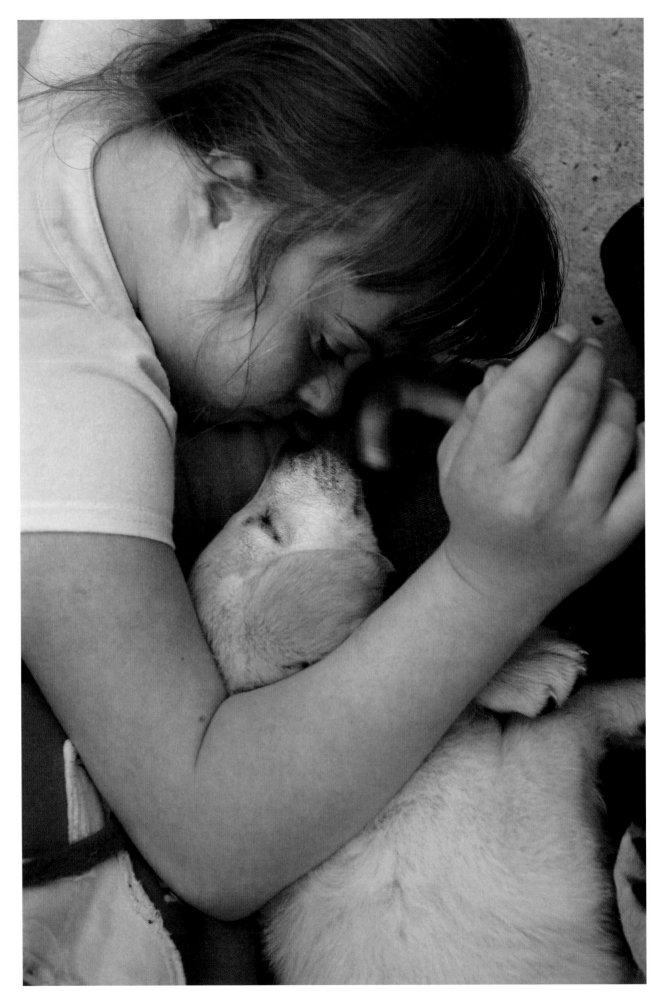

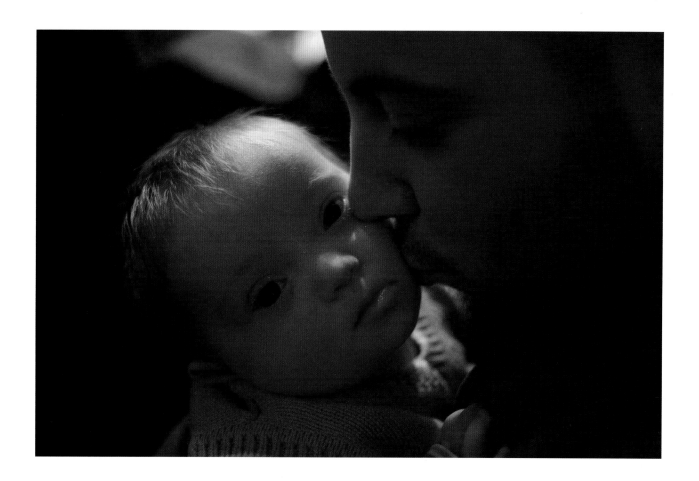

Amy and Ginny

Amy and Ginny, a child and a puppy, lie face to face on the floor. They stare at each other and remain still, two young friends secure in the knowledge that each is a source of unconditional love for the other. Each feels the other's warm breath and is comforted. Nothing else matters, for there can be no greater solace than that which comes from trust, from abandoning yourself to friendship.

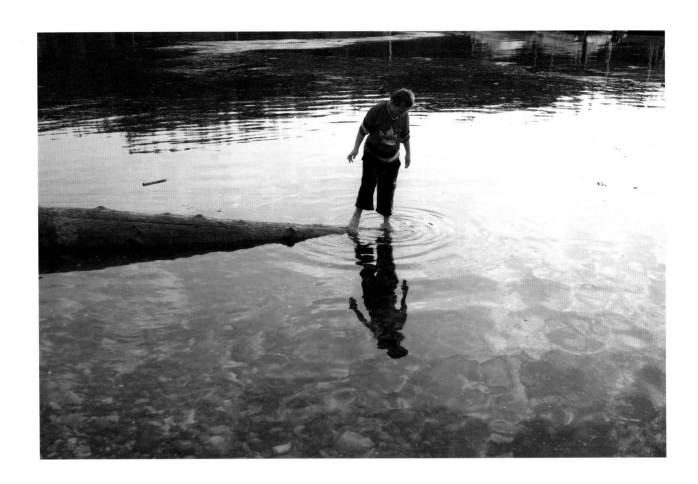

Apprehension

Luke and Olivia were overjoyed when, at the tender age of ten and twelve, they found themselves with a brand-new baby brother with Down syndrome. Adopted unexpectedly, baby David's arrival in the family had been rather sudden. But the novelty of having an infant in the house was palpable. After all, the baby's needs were not different than the needs that most babies had. And he was a lot of fun. You could simply hold him, and feel very special about it. They played with him and laughed at his antics. For a while.

As he got older, their baby brother became "a lot of work." True enough, he started having particular needs and required more and more attention, far more than his equal share perhaps. He became the centrifugal force in the family, because "everything that goes on in our family, everything that we do . . . is related around him and his needs." Without realizing it, "he forced us to grow up really fast," so much so that their role became more and more parental. True, in part it was due to their parents' age. Olivia already feels somewhat motherly, and she doesn't deny her fears for the future. I watched as she tenderly prepared David for bed. The twenty-two-year-old sat on the bed with her back against the headboard, one arm around her ten-year-old baby brother, as she read him a bedtime story, carefully pausing at the right places to show him the simple pictures in the book. It was a struggle to keep David's attention focused on the story, but her patience and perseverance won out. Just as she knew it would. David let himself be tucked in, one more hug, and with a tender look, mother-in-waiting dimmed the lights. Most people who don't have a sibling with disabilities cannot know how it feels to live with someone like David. The future is worrisome: What will happen to David when the parents can no longer look after him? What will befall them as siblings? How will it all impact upon their relationships with their future partners? For now, neither Luke nor Olivia has any answers, just apprehension. For now, David is quiet in the other room.

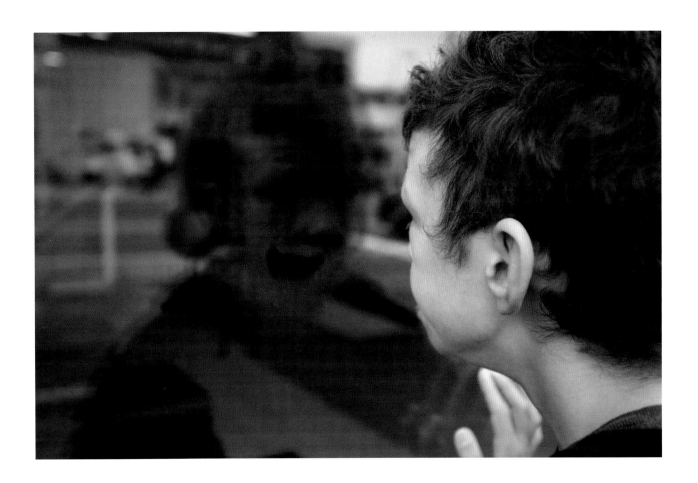

Reflection

A young boy, Luc, stops suddenly on the busy street, and stares intently inside the plate glass of a shop window. Oblivious to everything else, he is momentarily entranced by his own reflection, no different than countless children in cities and towns around the world. Except that Luc is used to being stared at in a way that other children are not. Is he different? He has pressed his mouth right against the glass plate, making a sharply delineated imprint of his tightly closed lips. The shape stands out clearly against the opaque reflection of the rest of his face. If he holds his head in the right position, the reflected face has an impish look, like the now-sad, now-happy face of a clown when he exaggerates and stretches reality into make-believe. How different is he? This is what I am reflecting upon as I watch him. But in a moment he bounces away from the window, back into the flow of life on the street. He is soon absorbed into the crowd of pedestrians and shoppers, and just as quickly, the imprint of his lips on the plate glass fades away.

Sound Surfer

Powell River is a small town on the coast of British Columbia, whose large pulp and paper mill is a testament to its origins. Long ago, it also became part of a pilot project with a mandate for community development, and it deliberately focused its energies at becoming an inclusive community. Its greatest accomplishment is the collective consciousness that it has nurtured for over twenty-five years, engaging in programs that demand thinking outside the proverbial box. Programs that have benefited people like John, a local musician.

It is a regular weekday morning in a group home on Ester Street. I follow behind, as John walks into a room and immediately starts to sing "*I have to cry sometime. I have to cry sometime.*" André, who is severely disabled and cannot speak, has been waiting for him, strapped into a wheelchair. I am the only other person present, and listen intently as John's mellow voice unravels the comforting tune: "*I lie awake at night. I lie awake at night. . . . It's all right, you know.*" John claps his hands in accompaniment, and the feeling is as soothing as a warm blanket on an icy night. Suddenly, I am jolted out of my reverie by a series of loud guttural sounds made by André, nonsyllabic to my ears, but piercing and sharp, and coming from somewhere deep within his inner being. John then plays his recorder for him, and periodically André responds in his shattering sounds that reverberate across the room and bounce from wall to wall. John pauses to explain that André "is a sound surfer. He rides the sound waves . . . the musical frequencies that I send to him, with whatever I play . . . flute, guitar, or piano." Does music not cross all frontiers? Does the experience of music not defy articulation? "It can take you out of yourself," says John. "You can't feel bad and play music. But sad music is also joyful, I think. Some songs will make you cry, but is that a bad thing? André loves music, and you can watch it as he rides with it."

John started playing music to people with disabilities informally, in his spare time after work as a community support worker. The effect on the listener's quality of life did not go unnoticed for long. He became an official music "facilitator" and now plays full time, going from house to house, like a traveling minstrel. He has organized a choir composed of people with disabilities, people without disabilities, and those "in between," as he puts it. He does not consider people as having "a disability or an ailment. . . . I choose a different realm. I am in this body because this is the body that I am in for this time. I have . . . many problems being in this body. André has a different set of problems." John and I feel privileged to watch André ride with the music across undefined frontiers.

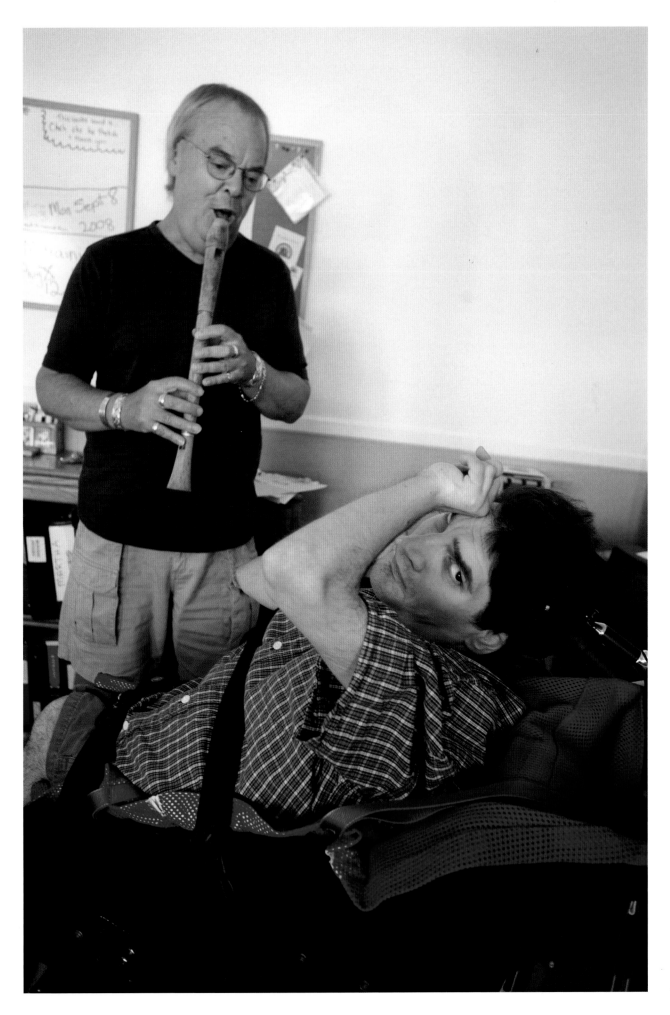

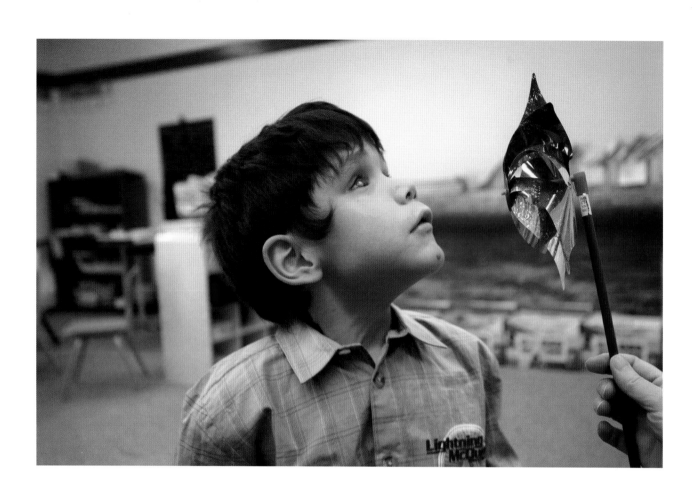

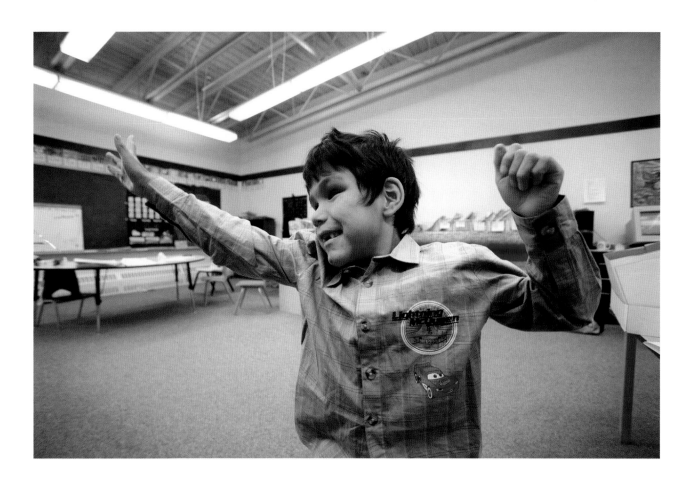

Doubt

Maurice and Mercedes are eight-year-old twins who live in the Arctic. Born with intellectual disabilities, they are also blind and mute. They live in a group home and are enrolled at the local Leo Ussak School in Rankin Inlet in Nunavut Territory. I am introduced to them in the classroom by one of their teachers. Before I can say anything, I am petrified at the improbability of the situation: I, a photographer from the far-away south, have come to make a picture of them, who are blind. What does it all mean?

I say hello to them as they approach me. "I have come to take your picture," I venture timidly. "How absurd," I think to myself. Maurice has been playing with a tambourine, holding it close to his face, and tapping the animal-skin surface of the instrument. Mercedes does the same with a xylophone. I brush Maurice's hair with my hand, and, in turn, I let him brush my camera with his free hand. I had just come in from minus 15 degrees Celsius weather and the camera was extremely cold. He is startled by the smoothness and by the cold feel of metal. I can *see* his pleasure at this novel experience. I let him hear the click of the shutter a few times. At that, he first smiles, then puts his arm and head against my stomach to hug me. I am moved by his gesture, my throat becomes dry, and my eyes, moist. Mercedes has been taking all this in, somehow, from a distance. I don't know whether I should be making this picture at all. My doubt is real and at first I feel incapable of the task at hand. Perhaps I am crossing boundaries that I shouldn't; perhaps I am failing in my task. But moments later I instinctively lift the camera to my eye, compose a picture, and release the shutter.

I don't know what this means to Maurice and Mercedes, if anything. Through a gesture of affection, I feel that I have their permission, though I wonder: will they ever be able to see the picture?

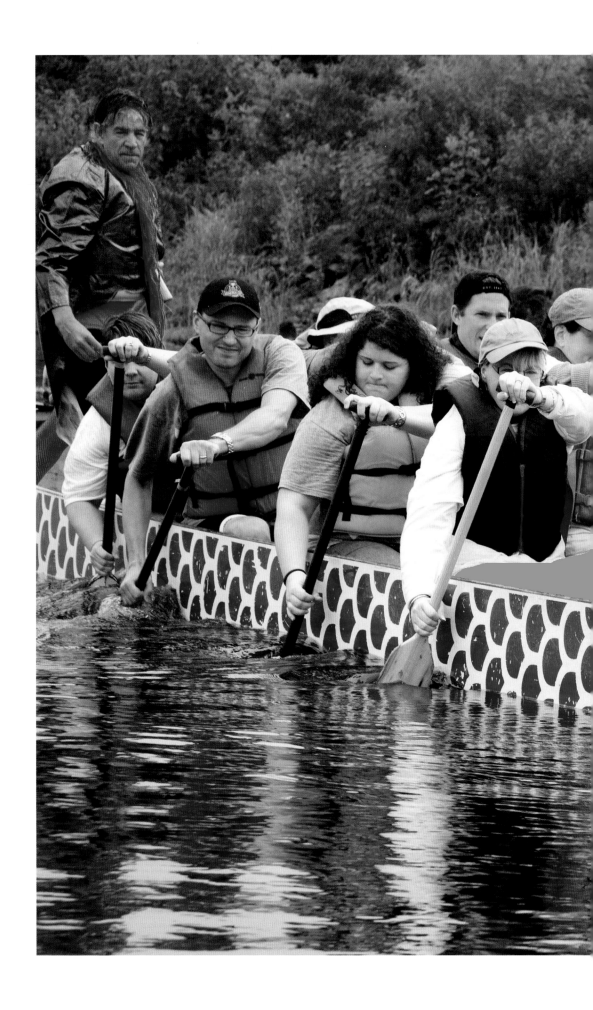

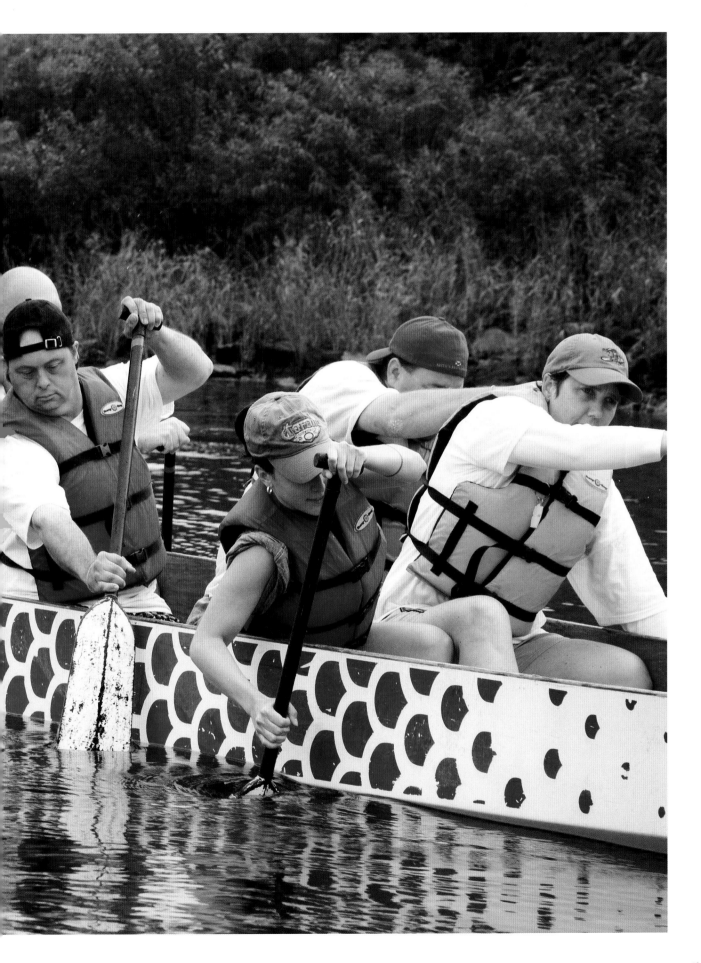

Navigating

I spoke with Emma in the minivan, while she was driving her daughter Alexis to a birthday party one Sunday afternoon in Edmonton, Alberta. Alexis, thirty-three, is severely disabled, and she is sitting in her wheelchair right behind her mother in the specially designed vehicle. She is a silent witness to our conversation: she cannot speak, although she can hear. Did she understand some of our conversation? I'll never know, and maybe it was a coincidence, but it seemed to me that as her mother retold once *again* some of the same stories that she already heard, Alexis let out moaning sounds, disconcerting for me at first, but soothing for her mother who knew how to interpret them.

We begin our conversation with Emma telling me that she came from a background where education and intelligence were an important part of her life, and that she was doing a doctoral dissertation on creativity and giftedness. Then Alexis was born, and she was utterly and indescribably shocked. "I felt the most piercing, keen sense of loss, of hopelessness in a sense. Not hopelessness, just loss, like death." As with many other mothers of children with disabilities, her life was radically altered. It took her eight years to accept her daughter for who she was, but she adds that her husband Joseph accepted her and loved her from day one. She became an assessment psychologist so that she could better meet Alexis's needs in life. She also became a professional activist, devoted to improving the life of people with disabilities. Alexis is her first priority, and she defied the dire predictions by the medical profession about her daughter and others like her. Alexis took away some of her mother's "rough edges, some of my own little selfishness, and preoccupations, and it helped me get things in perspective that I'm not sure would have been possible otherwise. I have a clearer sense of what's important in life because of her." The quest for creativity and giftedness has taken a new form, and now it is Alexis who comforts her mother. "When I hug her and hold her, she responds, and when she feels my angst somehow, she can be close to me, and gives *me* a sense of soothing that I don't get from other sources."

Emma keeps driving. It is common in Canada to drive vast distances, even within cities. The protective, comfortable, and private shell that is the automobile is conducive to creative and meaningful conversation. Emma does not miss a beat, steering on roads, highways, ramps, and circuitous residential streets in subdivisions like a professional driver on a mission, her eyes fixed on the traffic ahead, her mind focused on the telling, and her heart aimed at Alexis. Long ago she plotted a route for Alexis, and she's been navigating it ever since.

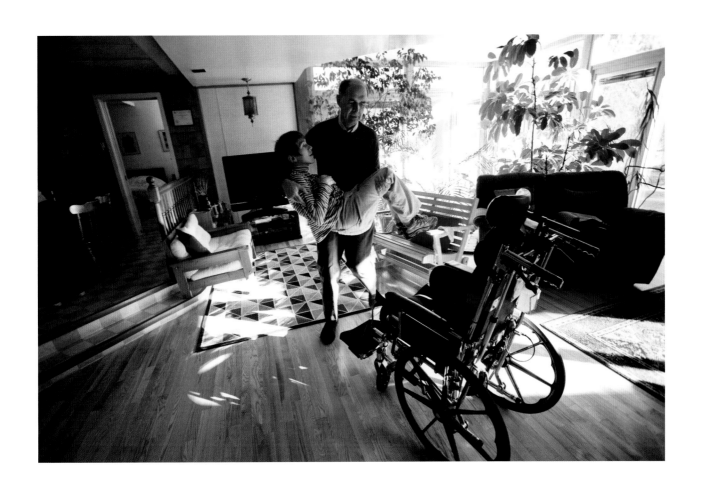

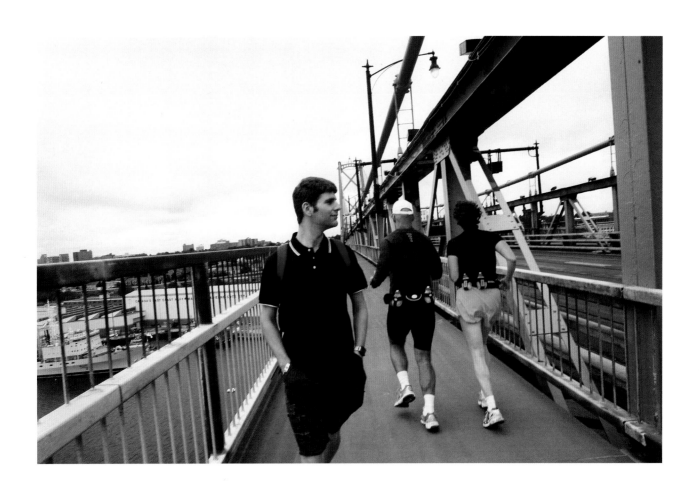

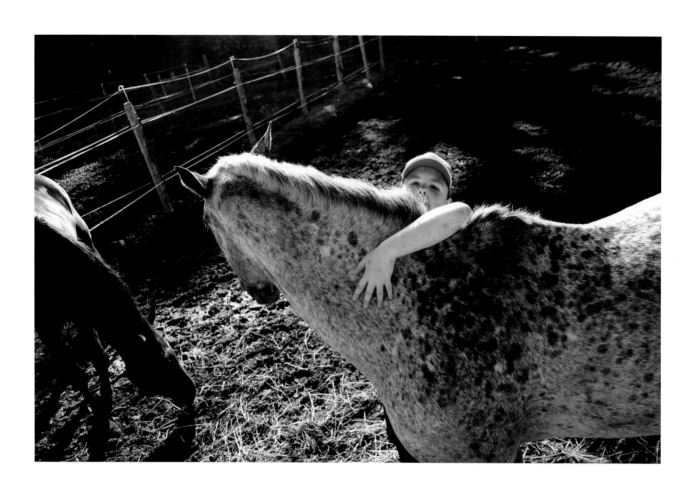

Acceptance

Jamie is a teenager who "more than anything in the world" loves horses. He is working part time at a horse stable outside Fredericton, New Brunswick, on a training program. He tells me that he has never loved anything as much, except his cat. Before he got this job, he stayed at home all the time with the cat, and that was "pretty much it."

Now, he can't wait to come to work, which isn't really work because he loves it so much. The first thing he does in the morning is clean the horse stalls. "I have to go out, dump their dirty thing, and take it out to the manure pile, and then get their wood shavings with a wheelbarrow, and dump it in their stall. I love it." Why do you love it so much? "It's horses." He doesn't ride them, he only looks after them. Outside, a brown mare seems to be waiting for his arrival, and she quickly responds to his staccato voice and boyish affections. The graceful horse and the lanky boy are careful not to brush their bodies against the live electric wire running along the fence, and so their first greeting seems clumsy at best. He feeds her hay, and then he fills a huge bucket with fresh water from a long heavy hose. He is scrupulous about making sure that the bucket, which is more like a half barrel made of blue plastic, is perfectly clean. As he fills it, the horse is already gorging, and Jamie feels the pleasure of the fruit of his labors. He continues to empty the slightest debris or leaves blown by the wind from every other bucket with water left over from the previous night. "Humans wouldn't drink dirty water; why should horses? It's not fair." The night before it had rained, and there were considerable pools of water in the paddock, with thick slimy mud all around. For a picture with his favorite horse, he gamely walks through the deep mud in the middle of the paddock, and tries to hug the mare with one arm over her back and the other around her stomach. He can hardly reach, and looks awkward as his head peers slightly over the straight back of the mare, staring intently toward my camera. As I release the shutter I can't help but think that this is exactly the way he would like to be hugged.

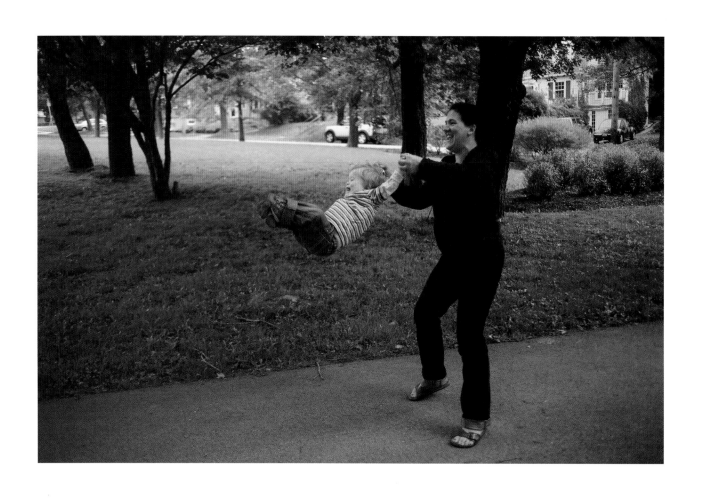

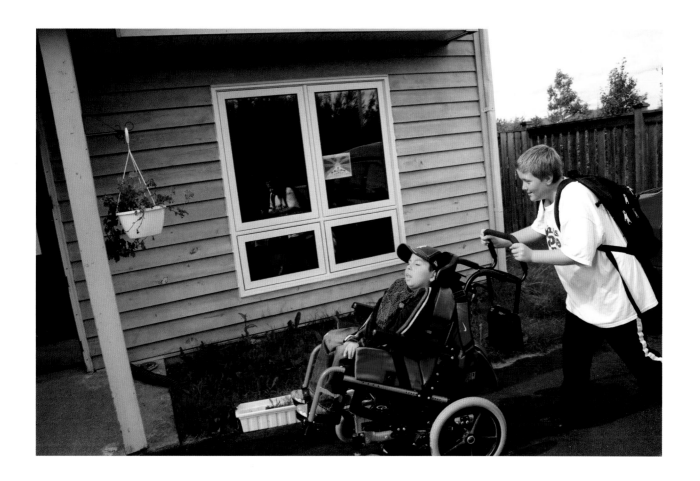

Making Raindrops

Every morning, Danny's friends meet him at the door, and they walk him to school, or more precisely, they push his wheelchair down the street, across the school yard, and right into their grade five classroom in John McNeil Elementary School, in Dartmouth, Nova Scotia. They do this again when school is out. On snowy days, up to twelve kids sometimes show up, and they scramble to clear a path for the wheelchair, in a small but remarkable community event—a veritable happening—that occurs on his street, called True North Crescent. What is even more remarkable is what occurs inside the regular classroom that Danny attends. Though he has no mobility or regular speech, he is very much part of the class all day long, doing his own science projects or poster presentations according to the curriculum, and of course in his individual program plan. The day I visited the school, the entire class was engrossed in a science experiment to make rain. Groups of children were gathered around workstations, where they first turned ice cubes into water, the water into vapor, and then through the process of condensation, the vapor turned into raindrops. Each child took a turn putting his or her head underneath the pan to catch raindrops that formed slowly at the bottom of the pan, only to fall dramatically to the ground. Not only was Danny participating as an individual, he had a specific task that his group depended on. Learning is a two-way road: beyond the making of raindrops, Danny is unwittingly teaching his classmates.

No Patronage, Please

We have just come in from a walk in the park. Alice puts on a kettle for tea, methodically places two cups on the kitchen table, and sits her two-year-old son, Alfie, on the rug in the adjacent room with some toys to play. He is alone, yet not alone, for the mother always has her eyes on him through the open French doors, encouraging him on, while she pays attention to her guest. The kettle whistles, she pours the boiling water into a teapot and brings it to the table. She sits down, and finally starts to relax, having performed this ritual of "a cup of tea in the afternoon" more times than there are leaves on the trees outside on Quinn Street. We each take a sip from our cup, and say, "Ah, that's good," just like we're supposed to say as we let the powers of the brew take us away momentarily from the routine chores of daily living. I press a button on the tape recorder, Alice smiles, and she begins to speak to me about Alfie.

"But you know, I am not so frustrated about the terminology because people get so worried about saying the right thing that they are scared to say anything, and you might say Down syndrome or Down's or Down's kid or whatever. Or that someone is retarded . . . but as long as you mean well, then I don't mind the terminology. It's just words. It's the attitude that I think is important. You can be told to change your words but people really need to be told to change their attitude so that they see people as individuals and they see them as people who have the same human rights as everyone else . . . and that they should be allowed to be the active citizens that they are. It shouldn't be that, 'Oh, we feel sorry for them,' and we let them somehow have some rights. *These are their rights*, you know, they're humans. We can't say short people don't have the rights, you can't say who has the rights and who doesn't. Their rights are inherent human rights. Not a charitable gift. Or patronage."

By now the tea has gotten cold. "I will make a fresh pot," she says.

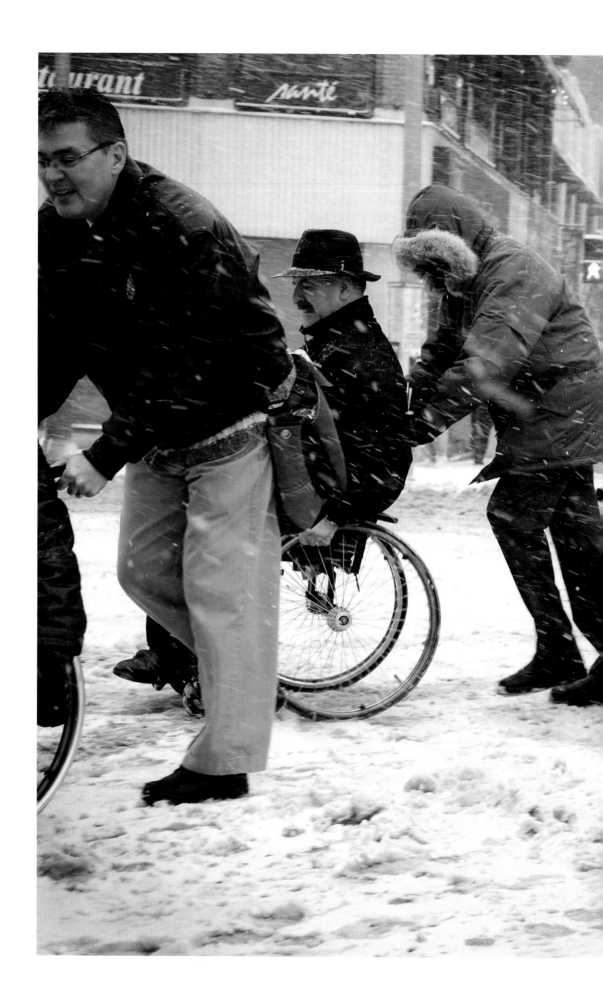

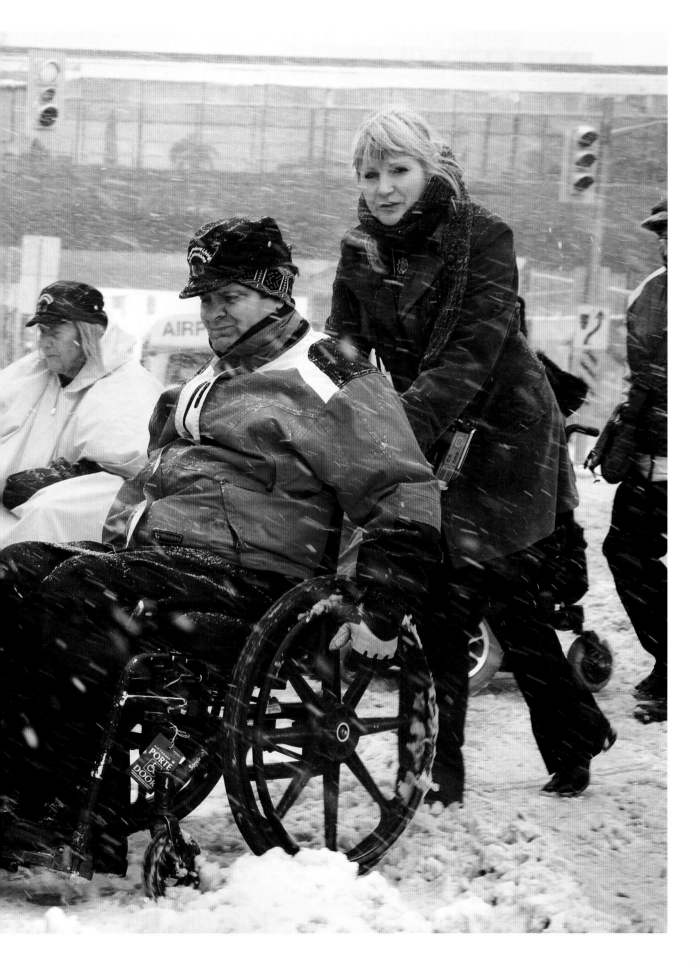

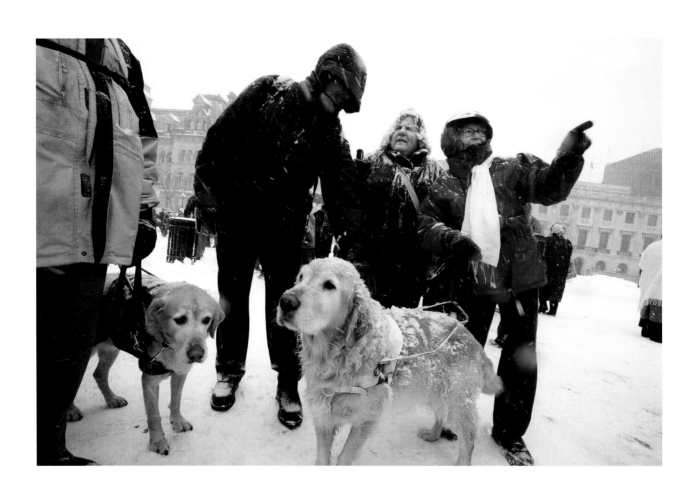

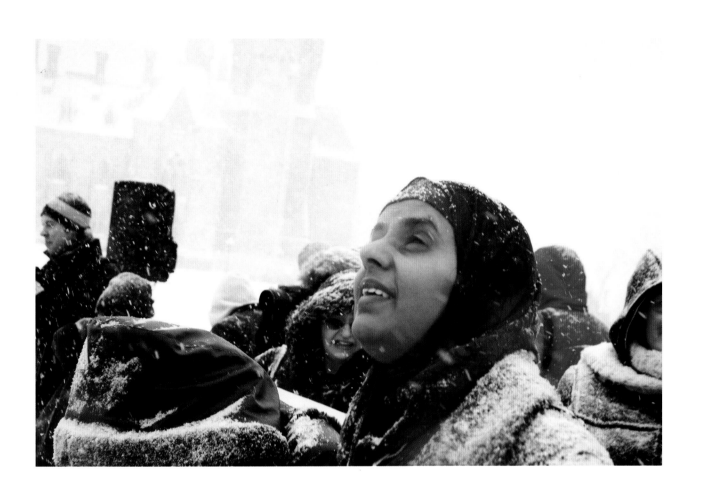

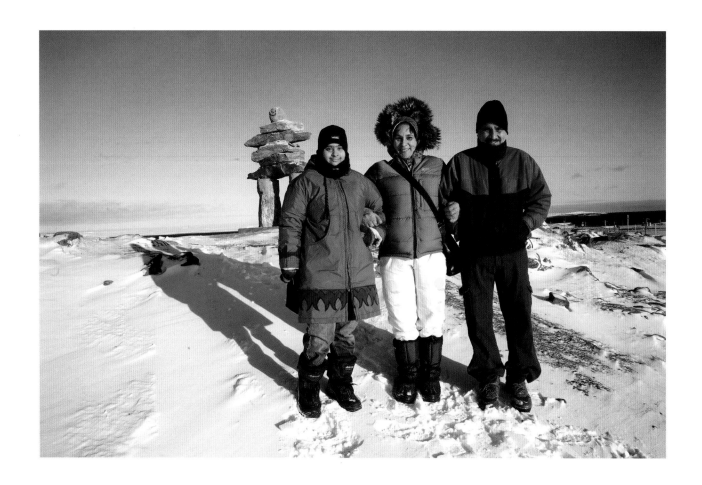

Immigration

As we stand underneath the gigantic Inukshuk, a traditional Inuit stone figure that towers on top of the highest hill in the town of Rankin Inlet in Nunavut Territory, we can't help remarking how unpredictable life's journey can be. Anna and Doigo and their daughter Dewlyn's search for a better life took them out of teeming, crowded, and hot Mumbai, India—one of the largest cities in the world—directly to this small, isolated, and sparsely populated Arctic community. On the day of the photographs, the snow is firm under our feet, and the wind chill makes the temperature feel like 25 degrees Celsius below zero. Though balmy by Arctic standards, at such temperatures the wind stings sharply, like a whip. Exhaling, you can see your breath solidify as it freezes, wafting upward slowly, as if it were engaged in a struggle to be absorbed into the clean air. You have a sensation of foreboding and vulnerability, and for Anna it was not unlike her feelings after she realized that her daughter had been born with a disability. Incomprehension, devastation, and shock: why did it happen to us?

But the grieving soon gave in to the beauty of the child, and as she grew, her talents shone in dancing, athletics, in the Paralympics. Now Dewlyn is working full time in a local hotel, contributing to the gross domestic product. Anna no longer sees "disability . . . it should not be a word that we use. We are all part of a community. Just as we have five different fingers, if one finger hurts, the others compensate. It's the same way." The Inukshuk, which towers above this town and punctuates the "land," is as enduring a symbol of inclusion as the stones from which it is built.

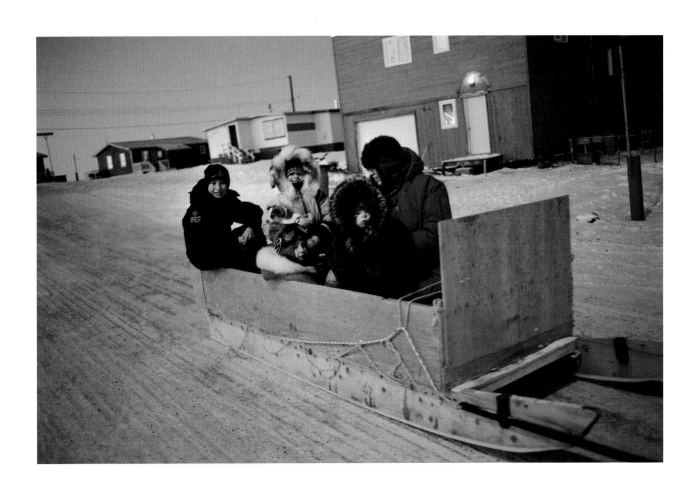

Bells of Inclusion

The chapel is tiny, modest, and lacking in much of the artwork and colorful adornment of larger churches, such as chandeliers, statues, paintings, and stained glass. There are no pews either, only plastic chairs, as befits the austere functionality of the square room; the low ceiling and neon lights make it look somewhat like a converted office space. This is a place of worship with no frills, where spirituality is the essence. The congregation is small, and it includes the residents of the local group home. One of them is Jimmy, who is in his forties and has a huge boyish grin, but not the ability of speech. He assists the elderly priest as an altar boy. During the consecration, upon a nod from the celebrant, he rings the bell three times from his kneeling position beside the altar; he is careful to do so at the right moments, in accordance with the rite. The bell has a sweet gurgling sound that wafts across the silent room. Jimmy is pleased with himself, and looks toward the congregation. He shuffles his body and smiles the big smile that he is known for. It is the holiest moment of the rite, and the worshippers bow their heads in devotion. But some look up expectantly, and gazing at Jimmy, return his smile in acknowledgment. It is a supreme moment of inclusion. Moments later, when communion is offered, all are invited to partake of it. There is a feeling of genuine sincerity in the air, as bulky parkas brush against each other and heavy boots shuffle toward the altar. The congregation breaks into the closing hymn in Inuktitut, the language of the people, just as the winds of a blizzard can be heard building up. The town of Rankin Inlet in Nunavut will soon be covered in snow.

Dance of Wheelchairs

Walking into the sanctuary at l'Arche Daybreak, in Richmond Hill, Ontario, I was overwhelmed by its simplicity and purity of form. It was a room of elegant beauty, remarkably bereft of superficialities. Built of wood on the edge of a pond, with a walk-out patio sitting on top of the water and featuring gigantic windows of clear glass, it seems as if the building is *bringing together* the elements of earth, water, and air, with fire represented by the burning candles. The exposed huge roof beams, and all other structural components, are polished to a natural state, revealing the grain *within*. A perfect metaphor for what the building's occupants aspire to. This is the spiritual center of a community where people with intellectual disabilities live in small households in familylike settings, together with the people who assist them.

The light of a glorious morning flows inside. Outside, the golden and russet leaves of maples sparkle, as if in prelude to what was to come. People stream into the sanctuary, some strapped into wheelchairs because of cerebral palsy and accompanied by their assistants. Osamu leads them into a meditative exercise that slowly evolves into a dance. A dance of wheelchairs. Moving to and fro in wide circles to the melodious music of reed instruments piped in from speakers, each person in the wheelchair swirls around in unison with his or her dancing partner. Bare feet and shiny wheels move in synchrony, transformed into sculpted forms by the brilliant sunlight that bathes one end of the room, then disappears into the subdued light at the other end, only to bounce back and be revealed again in the brilliance as they come full circle. In between these moments, the circle of dancers becomes an indelible circle of grace. The dancers let out the shrill shrieks, typical of people who don't have ordinary verbal abilities. And so the circle continues, turning and turning, until more than joy and more than laughter is revealed on the faces of the dancers. I recall how one of them, Rebecca, had written that she danced "for joy in life's gifts" but also "in sorrow for friends lost." The dancers stop just as exhaustion sets in, and the circle becomes disjointed in a final outpouring of emotion.

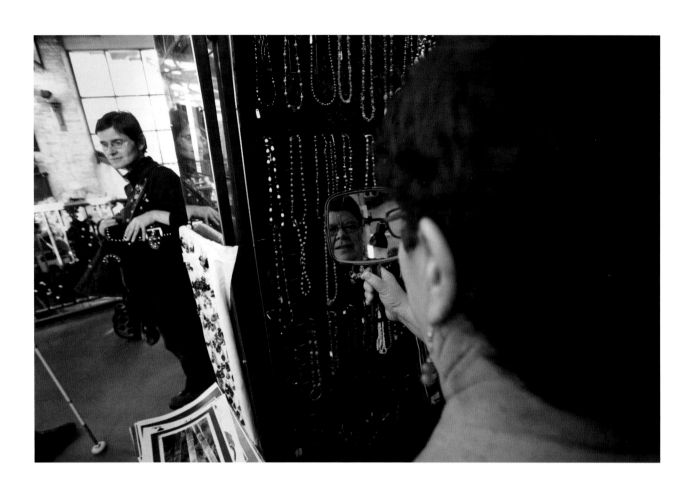

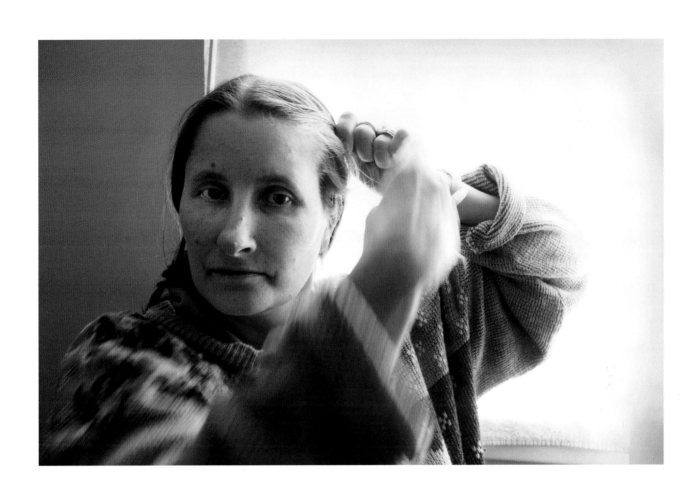

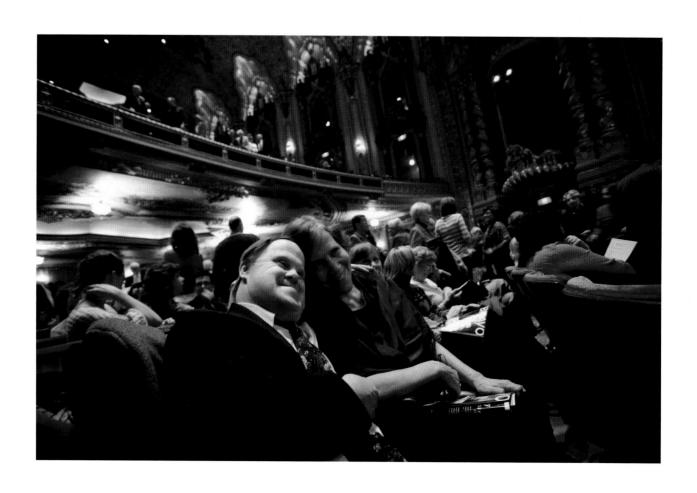

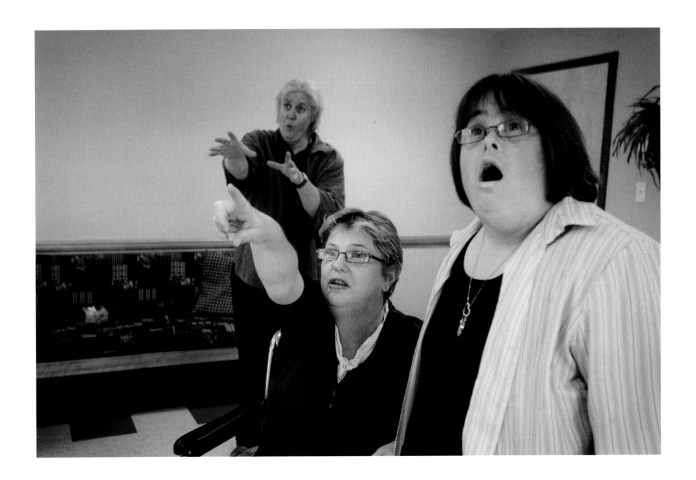

Theater

In Summerside, Prince Edward Island, a small theater troupe regularly performs stories about themselves, focusing on lives they have lived inside group homes. By converting their lives into stories for the stage, theater provides them first with an opportunity to look inwardly at themselves, and then with a means to convey "what is inside you" to the outside world. In theater, light metaphorically springs out of the darkness of the stage. These nonprofessional actors jump right out of the haze of group home life and stand on the stage to communicate with ease and elegance, something that their speech impediments usually make difficult or impossible. As the troupe re-creates a scene for me to photograph, Tasha, one of the actors, states that in the theatrical world of make-believe "they all hear you . . . and they know who you are."

The reality of those living a life mired in the constraints imposed by their own disabilities, compounded by the disabling actions and perceptions of others, is an inconceivable world of make-believe to those who regard themselves as being "normal." But theater turns it all around, as the inconceivable is paradoxically transformed into an unequivocal slice of reality. The magical world of the stage then is an all-inclusive medium for its capacity to render the invisible, visible; the incoherent, coherent; and the absurd, understandable.

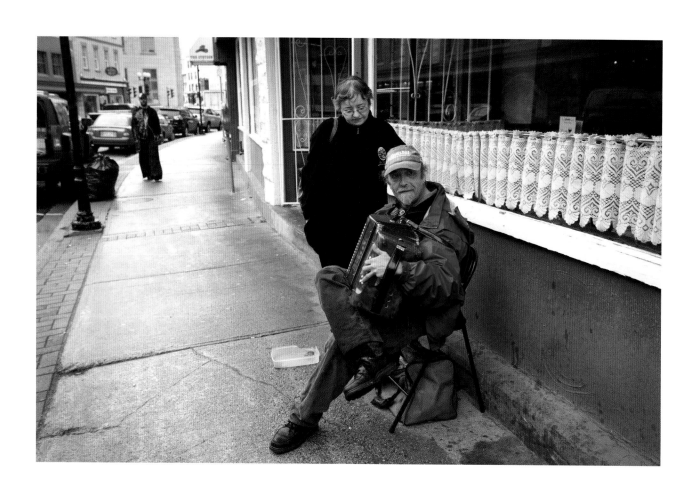

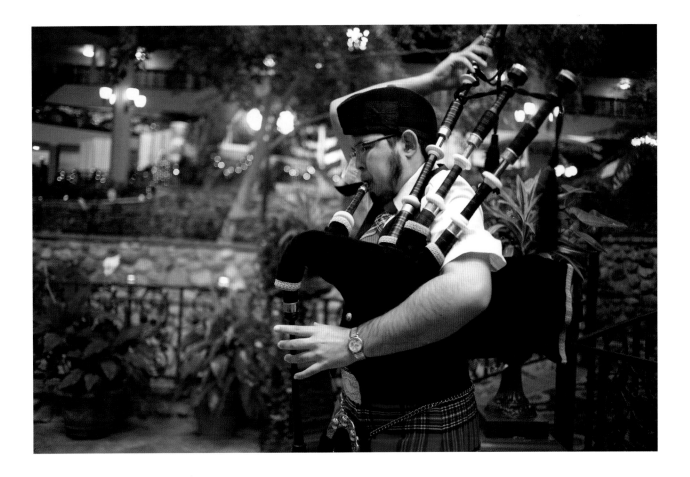

Max, a Musician

Max is a musician, and he mostly plays the Scottish bagpipes now. But he is not Scottish, he tells me imme-diately. He has also been a drummer, percussionist, and organist, and has had a love for music ever since he was four years of age. In his teenage years, he was part of a band, but left it because his fellow band members didn't really have any time for him and his autism. He wasn't cool enough for them, maybe, and they played tricks on him. He was different, and he was used to being made fun of. He was used to being taken for granted, or being ignored, depend-ing on whatever suited the people around him.

His best friend, a member of the Saskatoon Police Band, inspired him to take up the pipes. Five years later, Max is a piping master. But his friend died recently, succumbing to cancer, and the death left a void in Max's life. He would have been proud of Max who has purchased his own set of pipes by saving money earned working at a recycling plant. Max will continue to play the pipes, for music is a language of the soul. He says it's just "awesome," that's all.

I had planned to photograph him outdoors, by the North Saskatchewan River, but it was already November, and too cold—for the pipes, not Max. So we settled instead for the interior courtyard of a local hotel and convention center, which featured an aquatic landscape, with bridges, waterfalls, pools of water flowing into one another, and semitropical vegetation. Max emerges out of the bathroom wearing a kilt, and the scene is a little surreal perhaps, but not as surreal as the first gasps of the pipes in the moment when they start to come alive with each breath of life from Max's lungs. As expected, Max has now attracted too much attention, and it seems people have been dis-tracted from their conferences, conversations have stopped in midstream, guests walking by freeze in motion, a crowd starts to form, and management asks us to leave. Politely. Understandably. We oblige, of course, but not before admir-ers come by to shake his hand in approval. Max methodically dismantles the various components of the instrument, and carefully packs it in a brand-new case. On it is a bright red sticker that states: "I am Scottish!" He never told me what he actually was, except that he was Max.

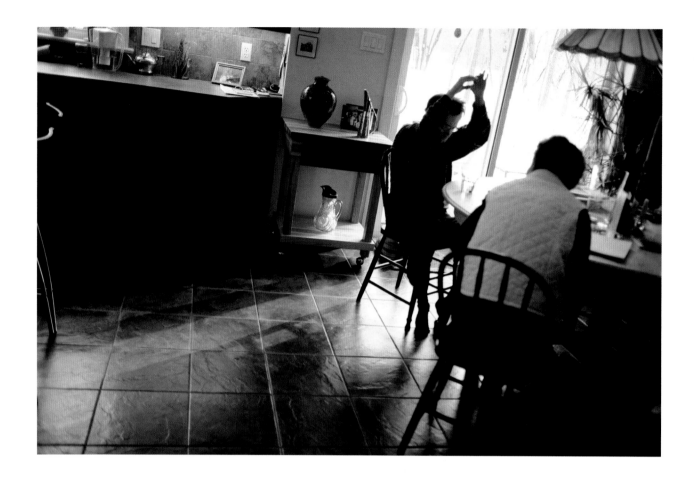

Opera Tales

Sitting on a sofa chair, Louis is listening to his iPod. Or trying to. He is a middle-aged man of fifty-four, and Charles, his uncle, has been attempting to take the gadget away so he can listen to the opera himself. His aunt, Yvette, is making coffee for them, keeping an eye on the blissful domestic scene in her home. It is a friendly game that the two men are playing, one they have played many times before. Charles is a tall, corpulent man in his late seventies, with big calloused hands that attest to a life of hard physical labor. Because of his size, he looks as fearsome as an ox, but when he looks at you in the eyes, you look back. You see a lamb in *his* eyes. He talks to me about Louis, and the lamb's eyes become moist. Louis had to be liberated from the institution where he lived for thirty years and from the unspeakable abuses that he endured. It was all through the efforts of his mother, Paulette, a tireless and fearless activist who wears her many years well. Her child is in his mid-fifties—even at an advanced age, a mature son is always a child to his mother—and he spends his time living the life of a free man. Doing the things that free people do, like playing with your uncle, if good fortune should so smile upon you. Or negotiating an iPod with him, so that two of you can share it simultaneously, and take in a few of the arias from the opera broadcast on a Saturday afternoon in the modest kitchen of a working-class family in the north end of Montreal.

All the while, I couldn't help but recall how, at a different time in my life as a photographer, I too was fond of listening to the opera broadcasts as I worked in my darkroom, with photographs swirling and gurgling in the wash tank while some forlorn tenor waxed melancholy about the unfairness of love and life.

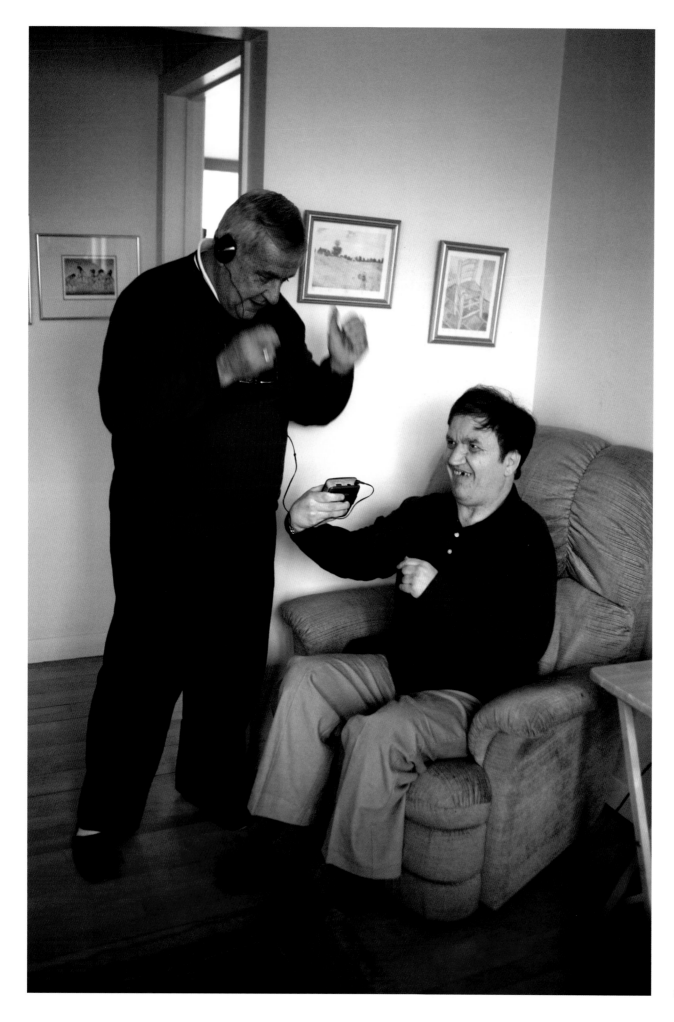

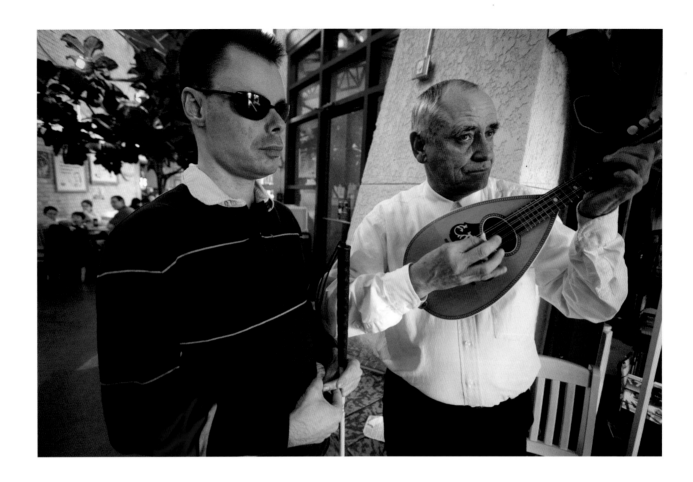

Confluences

Through the din of customers, sightseers, and assorted amblers on a crisp December afternoon, the music made by a mandolin wafts clearly through the stale air of the mall. Most people seem to ignore George and his plaintive instrument as he stands discreetly on the edge of the main thoroughfare of shoppers, as if trying not to disturb the throng. But his music has a haunting quality that transports you to places both distant and illusory in your memory. It creates a sense of peacefulness that etches a clear path amid the hubbub, much as a creek would assert its way through a thicket of forest growth.

Bob wears dark glasses like many visually impaired people, and he walks through the mall with the help of the requisite, regulation-issued cane on one side and the guiding arm of a friend on the other. Upon hearing the music, he gravitates toward George, haltingly making his way through the crowd. George notices the dark glasses and the determined face behind them. George almost starts to feel like a pied piper, and, pleased, he beckons the strings of his instrument to greater rhapsody. A few more chords and the two men are face-to-face. Two strangers bound by the power of music. The one emanates warmth through the music he creates; the other senses the warmth through the ears that he uses not just for hearing, but also in place of his darkened eyes. It's as if the two are alone in the crowd, yet no words are exchanged. The musician shuts his own eyes and, for a few moments, the two strangers are on the same wavelength. It is a tiny confluence of human tenderness between two individuals. The crowd of pre-Christmas shoppers is too caught up in its own blissful frenzy to notice, just as they are oblivious to the fact that they are inside a mall built at the confluence of two great rivers, the Red and the Assiniboine.

Like an Ex-Convict

Neil looks much older than his sixty-two years; his face is weathered, his voice is soft and submissive in tone, and he stoops slightly when he walks. When he was a ten-year-old child, he was placed in an institution for the mentally retarded, as they were called in those days. It was his rebelliousness, especially against his stepfather, that eventually cost him ten years of freedom.

Can freedom be quantified? Neil likens his life behind the institution walls to that of a prisoner, for like a prisoner convicted of a crime, he too was denied his freedom. Yet, his only crime was that he was deemed to be different from others, "mentally handicapped" according to "so-called normal people." Many times, he tried to run away. In one of his more daring escape attempts, he stole an ambulance and, with two others, drove all the way from Moose Jaw, Saskatchewan, to Winnipeg, Manitoba, before the police caught up with them. He was sixteen years of age at that time, and for this brief taste of freedom, he was punished, sent to a segregation or "seg" room. It was a tiny space, "with a big door that opened on the outside, and they would open it with a rod in one hand, and your tray of food in another, and if you came in anywhere near them, they would poke at you with the rod. . . . You know how, like, if you're a farmer . . . when the cows or the pigs come up to eat, and you're still trying to pour their food in there, then you poke them with the rod. That's what they used to do to us."

As he tells me this story of darkness, the sun shines brightly in his modest kitchen in a high-rise apartment. Today, he has a spectacular view of downtown Saskatoon. A few years ago, a psychiatrist concluded that "I'm not what used to be [called] mentally retarded . . . I'm not. I got a brain injury only . . . so when she told me that . . . that blew the kettle right over the pot!" But in his sardonic sense of humor, he still refers to himself as an "ex-con," not as a former resident of an institution. Perhaps it is his way of making sense of a senseless ten years and a life forever scarred by the experience.

Family

The dinner table is being set once again, as it has for years, in this farmhouse in the countryside near Ashville, Ohio. Van, who lives with his parents in the city, has come to visit his sister Kathy and her family, a joyous reunion that always culminates with a celebratory dinner. It is early spring, and the surrounding brown fields are dotted with patches of delicate green, shades of new growth that are ephemeral at best as the season quickly unfolds into summer. Van methodically fills the long-stemmed glasses with ice water, carefully balancing a jug in one hand and a glass in the other, oblivious to the commotion and chatter in the adjoining kitchen. Now and then an ice cube spills into a glass, but this is a deliberate action, for Van is in total control as revealed by the look of satisfaction on his face. I have been with him all day now, and have seen how much pride he takes in helping out with the family chores. And I have already forgotten that he has a supposed disability, having been born with Down syndrome.

We sit for dinner and join hands to make a circle, giving thanks through song and gesture, ending in a chorus of laughter. I cannot remain unmoved by the sense of constancy that is palpable in such gatherings. I am reminded of how a family is usually the first circle of inclusion, for people with intellectual disabilities as for everyone else. But I have also seen how disabilities might drive a family asunder. A family is a safe haven, yes, but it can also be a testing ground for its members, an arena where they may face the struggle of their lives as they cope with the challenges of intellectual disability. Everything always requires careful planning, fine-tuning, and preparedness for emergencies. Some people are deeply tormented as they struggle between the deep love they feel for their relatives and the challenges of family life. Sometimes a partner leaves; more often than not it is the husband or father. But the family usually triumphs over hardship and disability; it is still the ultimate refuge of unquestioned love, commitment, and care.

As dinner comes to an end, the fields are already dark, and the soft shades of springtime green have been absorbed into the twilight. It occurs to me that Van's disability had long ago been absorbed by the rest of his family.

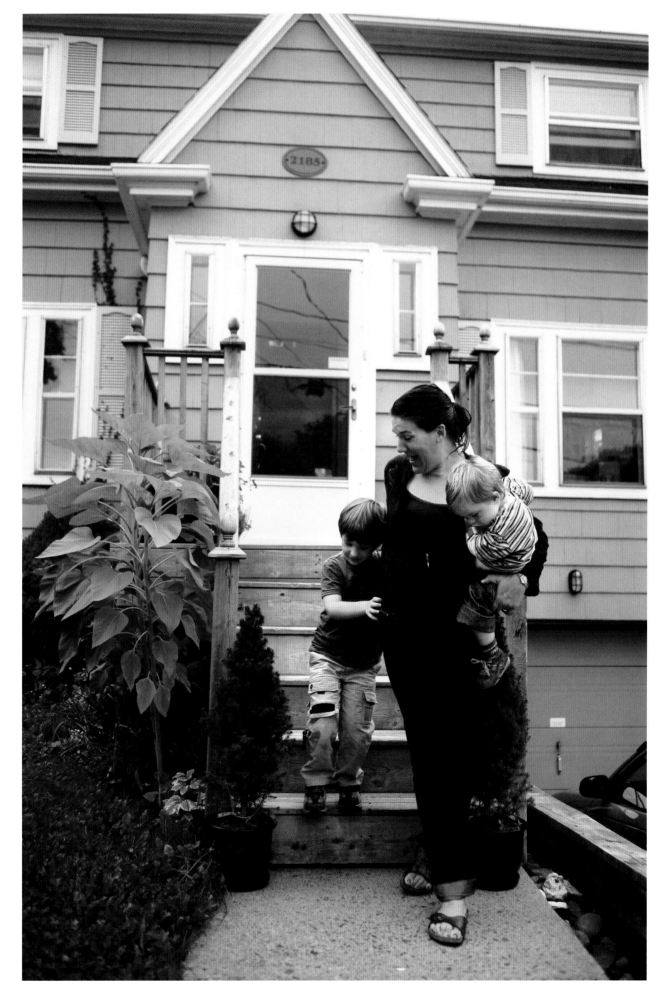

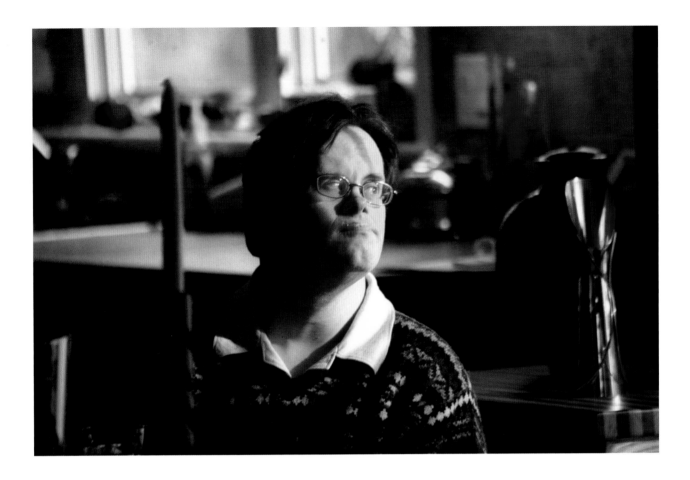

A Piano Concerto

Ian and Diane are sitting at her kitchen table listening to music. It is a cold, windless day, but the late winter sun sends welcome rays of sharp light through the curtains. Outside, the snowy landscape is still, punctuated by Buddhist statuary and tall ornamental grasses that are yellow and dried out. Some of the rays of light shine on Ian's face, and he looks radiant. He sits very still, and his face has a sort of serenity about it that reminds me of the Asian faces that are carved in stone out in the garden. And like them, he has no voice to speak with. He is in a soliloquy, totally absorbed in Mozart's Piano Concerto No. 21 *andante*. Occasionally, he munches on a cookie, takes a sip from a glass of juice, and then quickly reassumes his listening posture. Diane has been watching him intently. She is his music teacher, and they listen to music together three times a week. By now she understands exactly what his favorite music is. The first time, she was so moved by the experience that she cried. She watched him become one with the music. On the day of my visit, the teacher said, "It's through him that I've learned to listen."

Later, I ride with Ian in the minivan, sitting beside him in the back seat. He is still absorbed in the music, and re-creates every movement in his mind. As the vehicle speeds down the country road, Ian "conducts" in silence, making patterns with his hands. Maybe they are random, maybe not. From my vantage point, his moving hands are silhouetted against the snow in farmers' fields, framed by the car window. It is easy to imagine some of Mozart's hauntingly beautiful notes that Ian is hearing in his mind.

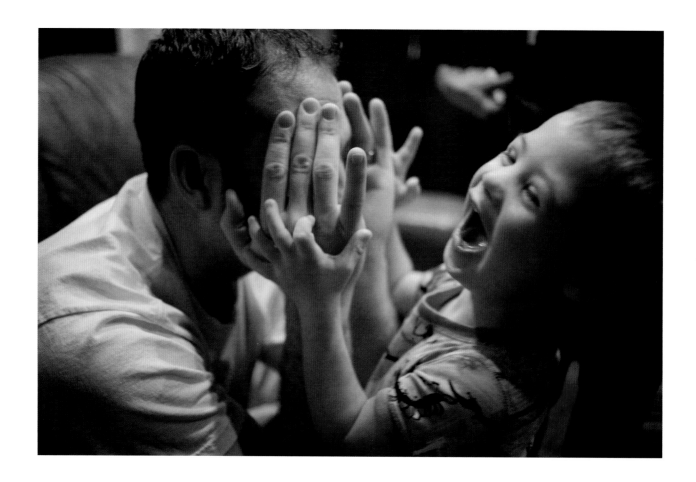

Baby Brothers

On the day that Gabriel was born, his two-year-old brother Jack walked for the first time, right into his mom's hospital room. It is always a momentous occasion when a child walks for the first time, but in this case, it was especially so because Jack had a medical history wildly disproportionate to his young life. While still in his mother's womb, at thirty-five weeks, he was on an emergency flight from Yellowknife in the Northwest Territories to Edmonton in Alberta. They found two holes in his heart, and he could have been born with "multiple, multiple genetic syndromes. When he was born, we took a look at him, and we knew he had Down syndrome. He was healthy, fine."

Shauna and Michael's dream of making a family had just been turned upside down. Were they ready to raise a child with a disability? Is anyone ever ready for that? What is a disability? But what worried them the most was that their child had a serious heart ailment, and they were afraid he was going to die. He spent the first ten weeks of his life in the intensive care unit. Shauna was determined to breastfeed him, something that she had so often dreamed about, and so she assiduously pumped breast milk, and for the first ten weeks of his life Jack was fed his mother's milk through a tube. At the ten-week mark and less than ten pounds in weight, he had open-heart surgery. And then he was readmitted for postoperative care. "He's definitely a little miracle baby, too."

Gabriel and Jack are playing together, as they always do. There is a special bond between them, a special way of communicating. Jack can't speak, so he often yells in frustration. But somehow, the two-year-old Gabriel has learned to talk to his older brother, and knows how to calm him down. Shauna is pregnant with her third child and the two boys take turns listening to the noises coming from inside their mother's big belly. Of course she's afraid, as she was the last time, too. "We always wanted to have three children. And then we're done. Yes, we are. We are *so* done."

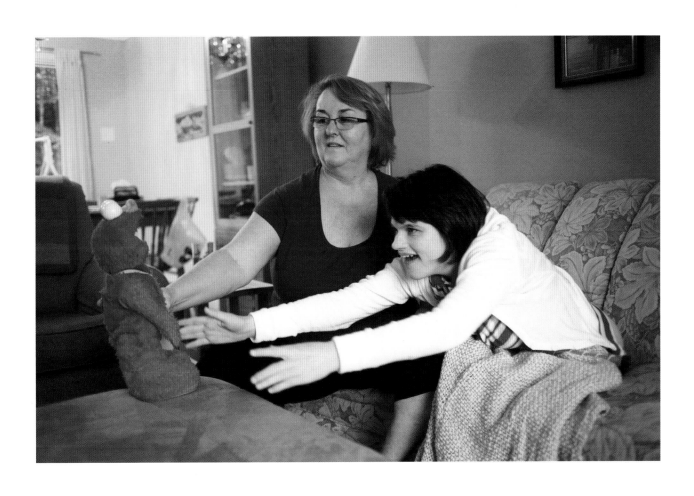

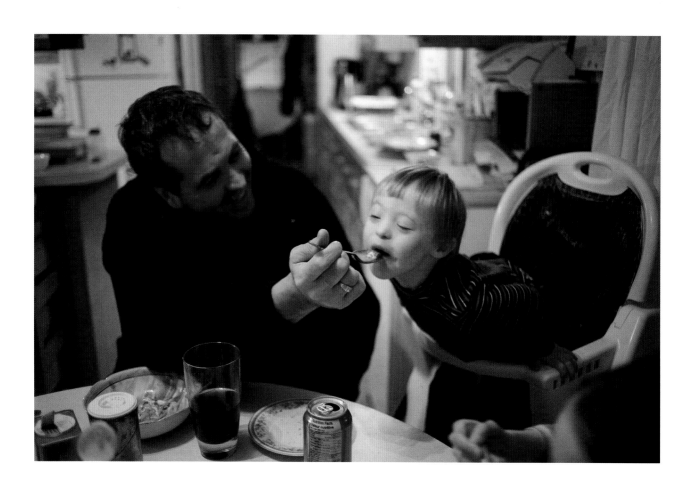

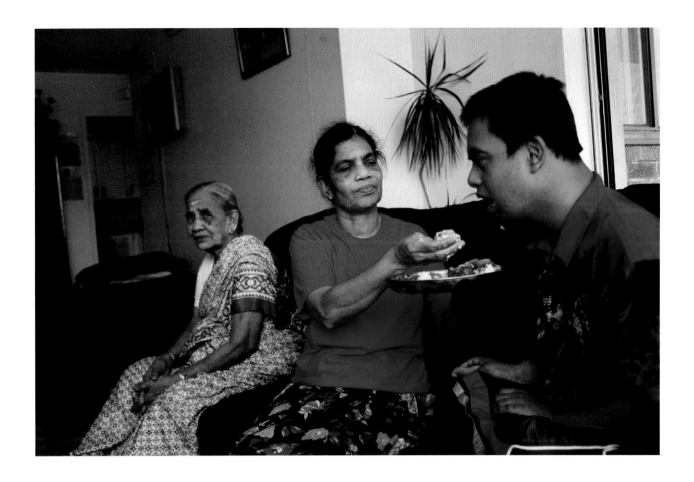

Dinner

"Hey, come on, hold your head up," Joseph exhorts his daughter, Alexis Antonia, as he feeds her dinner. She droops her head, as she often does. Tonight it's chicken, broccoli, green beans, and sweet potato, all puréed. Sometimes it's salmon, "the good stuff," he says coyly. With his left hand, he gently holds her head up from the forehead, and with his right hand he places a spoonful near her mouth, all to the soft strains of Anne Murray in the background crooning something about being "in need of me." Alexis chews and swallows, relishing the taste. As she droops her head down again, he whispers ever so softly and lovingly in her ear, "It's broccoli . . . it's broc-coli . . ." She takes another spoonful, and droops her head once more while she chews. He waits, and now he droops his head, resting his cheek on his left hand and elbow.

This could be a rather ordinary scene between a father and child, except that Alexis is thirty-three years old. She has multiple and severe disabilities: she is blind, has no functional use of her hands, has no formal communication system, and cannot sit up independently. The scene between Joseph and Alexis is so tender and intimate that I didn't feel I had the right to intervene with the sound of the camera. I recorded it only with my eyes and a pen.

No one needs to see a picture of Alexis chewing her food.

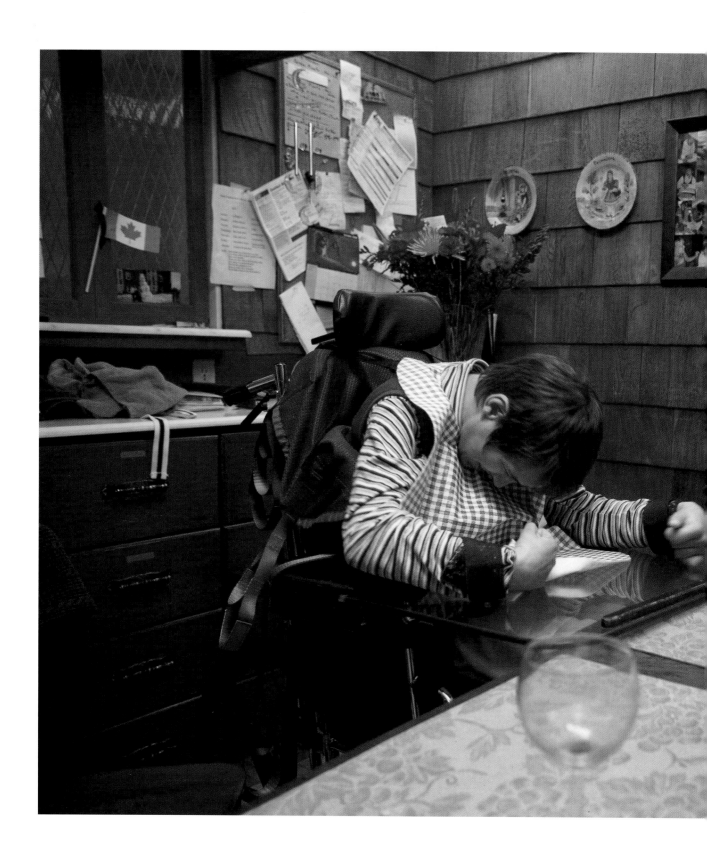

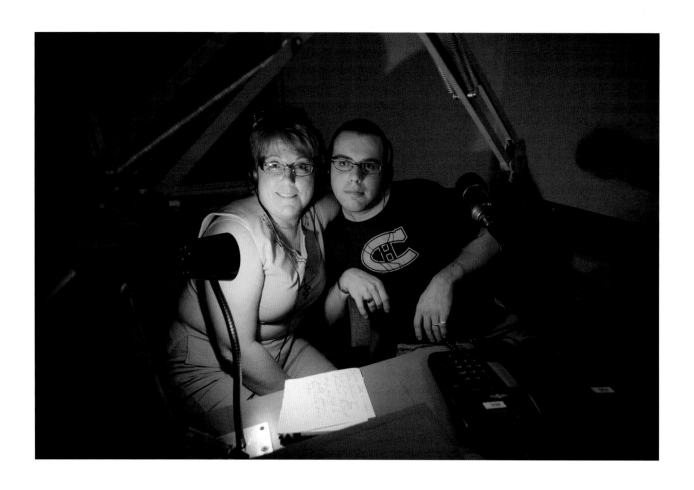

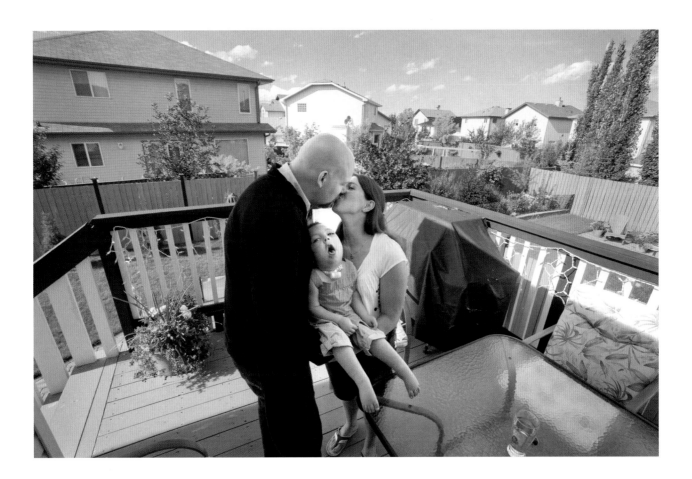

Baby Won't Cry

Driving back home from an afternoon of shopping, Christina and Chad were hit by a stolen car that was being chased by police. It was a devastating accident, more tragic than the young couple could have imagined at the time. Christina was twenty-eight years of age and pregnant with her first child. Her spleen was damaged and it ruptured. The unborn child was deprived of oxygen for possibly some thirty seconds, but her brain stem cells calcified and died. The infant Jaina was born without the basic life reflexes, "so . . . she can't suck or swallow, gag or cough . . . she can't take deep breaths, she has to be ventilated, and suctioned, and she eats through a tube."

At first, the new parents' denial was deep, abetted also by the doctors and nurses at the hospital, but soon Christina and Chad gave up hope of becoming the parents of the child they had dreamed of. At first, they grieved for the child they thought they were going to have. But in time, the child they had did become their angel and teacher, teaching them patience, and love and acceptance, teaching them to love in ways that they had not thought possible. They learned "her language" and how to communicate with her, to focus on what she could accomplish. They learned about extensive medical care and had to become health experts simply to be parents. Through the early period of shock, Christina was in a stupor: she would never breastfeed her baby. It was a dark time in her life; only her journal gave her internal strength amid the uncontrollable crying that marked her daily existence.

Crying . . . to hear her baby cry in her arms! To hear herself say, "Hush, child, hush!"

Christina always thought that one day she would have a baby that would cry, like all babies do. But Jaina will not ever cry. When she hears mothers complain about their babies crying, Christina secretly feels a pang of envy: "I wish my baby would cry."

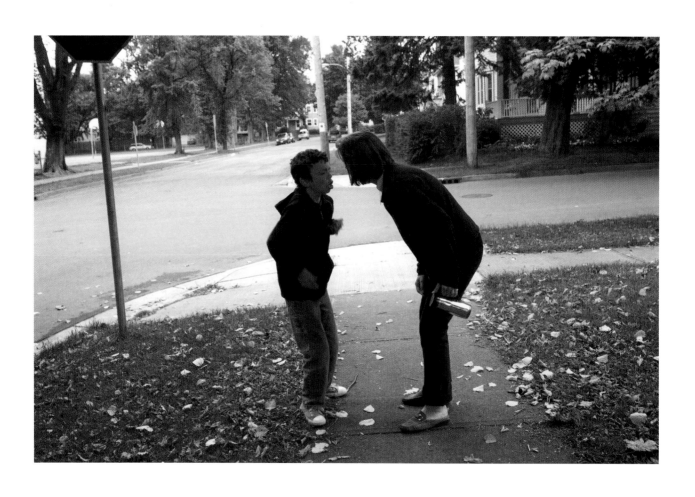

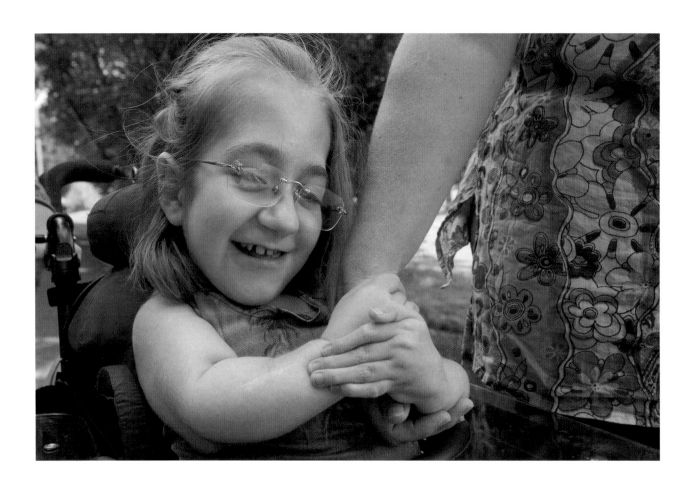

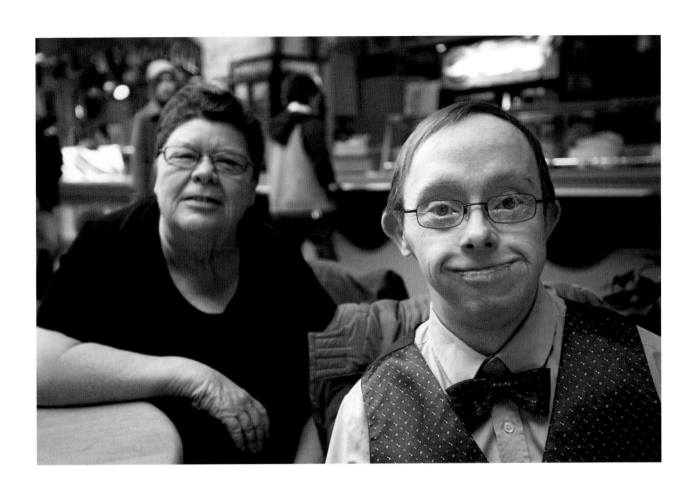

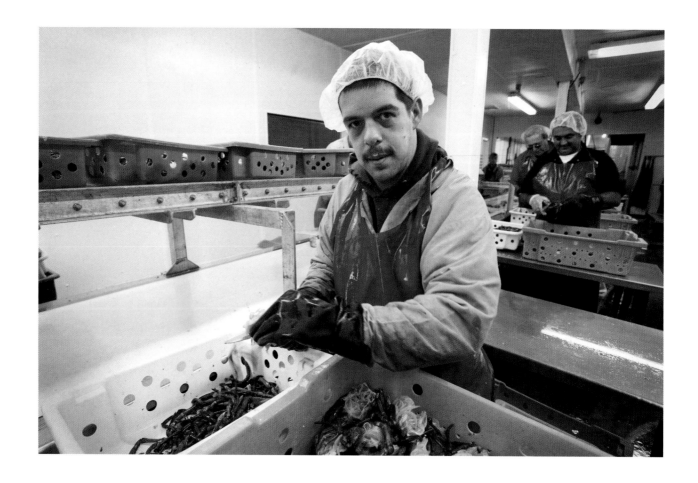

Working for a Living

The right to work is a theoretical concept that is one of the pillars of our society, even though in reality it is enshrined in law only by few jurisdictions around the world. The right to work translates into survival and independence, self-esteem and fulfillment, and a means to personal expression. Not having any work means economic dependence and vulnerability. People with intellectual disabilities are routinely denied the possibility of work, and even when not denied that possibility, they are often offered *nonmeaningful work*, tasks that may have been created just to fill their time, to keep them from being idle, but which are only useful for justifying misguided notions of charity and inclusion. Sometimes they are compelled to work on a volunteer basis in the long term, when in fact they should be working for pay. To bar someone from work is to exclude them from the "production" side of society, as if to say, you have nothing to offer, you are but a *burden* that we have to contend with.

What happens to persons with an intellectual disability who have the opportunity to work in the same conditions as everyone else? Like all workers, they will feel like ordinary people: a destination every morning, and perhaps a goal every day. They will partake of the daily rituals of work. As they change into work clothes they reveal to themselves and to everyone else another layer of self-identity, and they belong to a great collectivity, the community of workers. At the job site, they excel, and far from the ordinary workers that they try to be, they become extraordinary. But they do something else: every time they punch a time clock, they are challenging the barriers of exclusion.

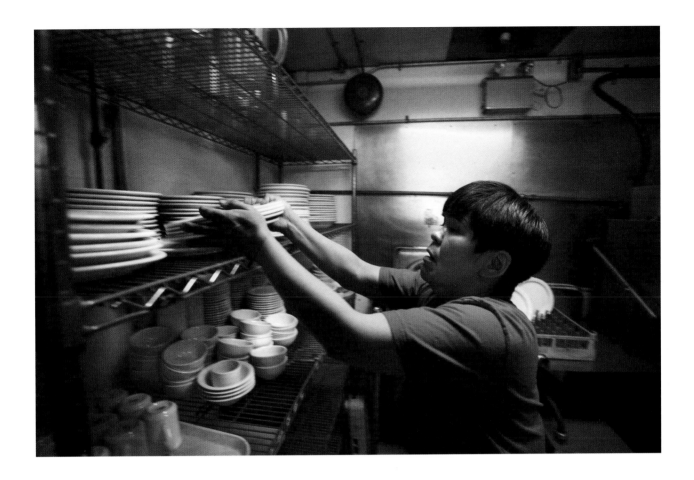

As I photograph Mary Jane operating an industrial dishwasher, and washing by hand the huge pots and pans and assorted equipment of a hotel restaurant kitchen in Rankin Inlet, Nunavut Territory, I can't help but notice how she meticulously checks every single dish that comes out of the steamy appliance for spots and stains. She piles those that fail inspection in the deep stainless steel sink, to later scrub them by hand. She makes a final check as she stores the clean dishes on the shelves. All afternoon, she works with compulsive enthusiasm, splashing so much water on herself that by the end of the process, she looks as if she had taken a bath. The hotel manager, in the meantime, tells me that "she's my best worker . . . I wish I had three more like her." This was a refrain that I have heard regularly from other employers, in fish-processing plants, courier services, offices, and even a construction company that worked in specialized fields, such as framing, dry walling, window installation, and concrete. A manager in a plant in Cap-Pelé, New Brunswick, proudly pointed out that Mathieu, despite his disability—which was not apparent to me—easily keeps up with his coworkers on the conveyor belt cutting lobster and making it ready for packaging. "He hasn't missed a day in seven years, and he is reliable, . . . I would say more reliable than some of the other employees." In our conversation, I noticed that in a slip of the tongue, he says "special people," but the utterance of this label rings false and awkward, especially in the context of the workplace: neither Mathieu nor Mary Jane has needs that are different from those of any other worker.

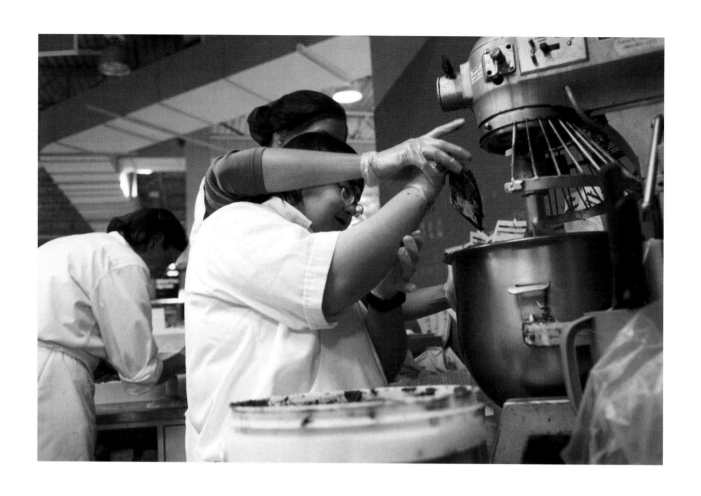

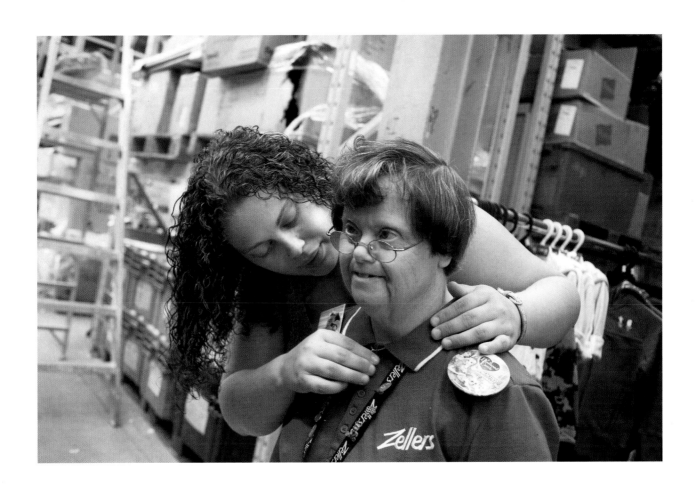

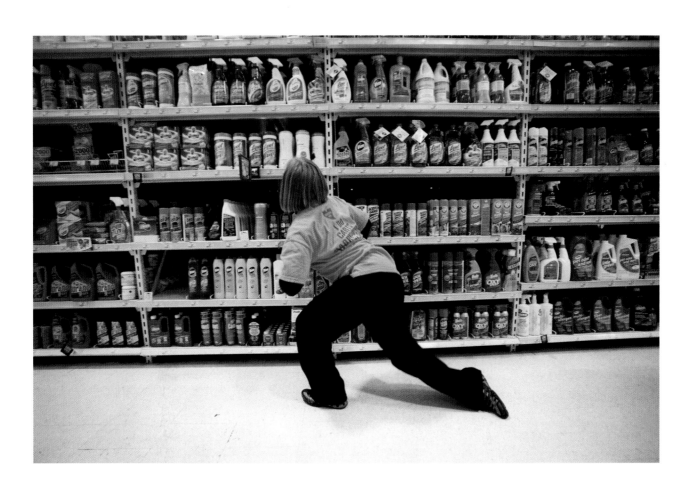

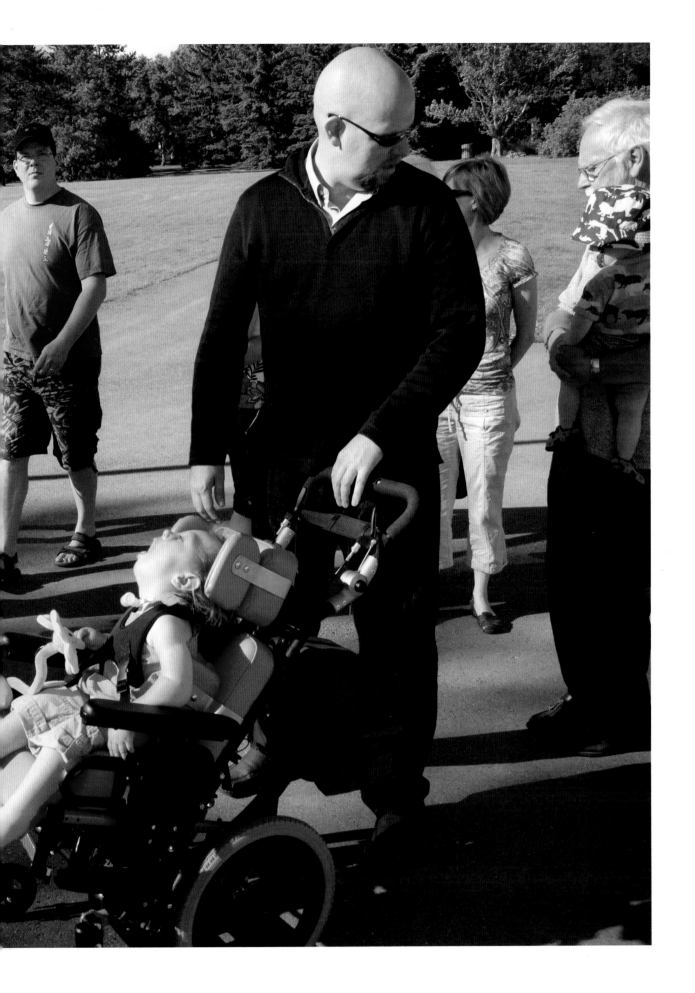

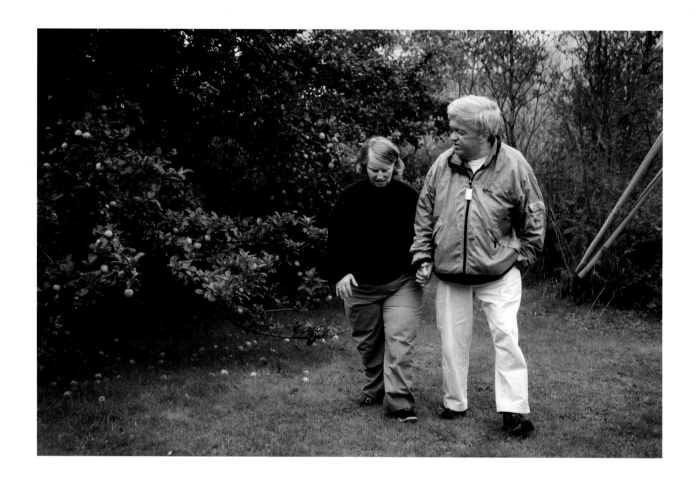

A Walk in the Park

Seclusion was a way of life for far too many people with intellectual disabilities. For their own good, it used to be argued, to keep them from harm's way.

Gail and Bob are a middle-aged couple living in Newfoundland. Shy at first, they venture out reluctantly into a misty garden behind their house for a portrait. Holding hands. A moment of quiet tenderness. With their eyes, they said this is how they would like to be seen. They would like others to know about them. They are not afraid of the camera lens. They know that when the eyes of the world will look at them through a photograph, they will be out of harm's way. Not like the unkind stares of countless strangers that they have known throughout their lives. They smile reflectively, and like all couples in love, speak to each other without the need to say the words. I sense that their walk in this secluded garden will become a walk in a park before long.

Across the country in northern Alberta, another couple, Christina and Chad, go for one of their regular walks in the new park of a subdivision. They push a stroller with their severely disabled baby daughter, Jaina, in the afternoon sunlight. They stop now and then to watch a group of children throwing stones into the pond, making them skip and skim over the surface of the water. The children scarcely pay attention to them.

A second family arrives to share the path. They are also pushing a stroller with a baby, but this child has no visible signs of disabilities. The two families simply smile, acknowledge each other with kindness, and go their own way. Christina and Chad have also opted to make the park their own, and this is where they belong on a Sunday afternoon. They have woven themselves into the fabric of the community, and simply by their presence, they are challenging attitudes and altering perceptions about disabilities.

Young couples like Christina and Chad are being inspired daily by older couples like Gail and Bob, trailblazers who have been carving paths of acceptance in communities halfway across the continent. Holding hands, for all to know.

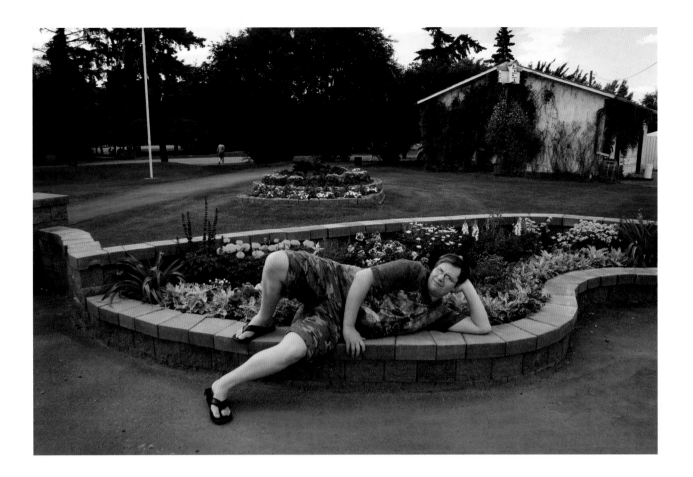

Cyberspace

When Richard was born, his umbilical chord was wrapped around his neck for a few precious seconds. He lost oxygen, and "I now have a disability . . . but I just don't throw it to people . . . I think they say I was mentally disabled." He has been openly gay since the age of seventeen, when he was "kind of pushed" into coming out in his life skills class. It was 1997, and he was "devastated, sad, and scared of how people would treat me. I had a lot of death threats. People wanted to pick fights with me. . . . Mom thought it was just a phase, but in time she realized who I was, and that I'm not going to get married with two kids, and a dog. . . . There have been many times in my life when I just wanted to throw it away . . . there are times when I'll be crying for hours and hours a day."

Richard realizes that the Internet offers opportunities for self-esteem and empowerment. His dream is to create a Web site for gay rights and disability rights. He speaks eloquent words about inclusion and exclusion. "What I believe is . . . gay and disabilities don't have a world where we're right here. We get treated differently than others. . . . This is my personal preference, what I think: if you're straight, and—people hate this line—normal—you don't have a disability. You're welcome in this world . . . but once they find out you're gay, you get gay-bashed by straight people, and if you've got a disability, oh, you're just a little child. They treat you like a kid . . . that you can't do very much. And it's hard, and it's hurtful, very stressful, too. When you have all these other people that think they're smarter than you, they're either stupid or they just think they're better than you . . . even though in our world, no one's better."

The Internet will provide the sense of belonging that Richard has longed for. Unlike his real world, he is discovering that the virtual world of cyberspace can be a place of inclusion. It is empowering enough to propel him on his quest for social justice.

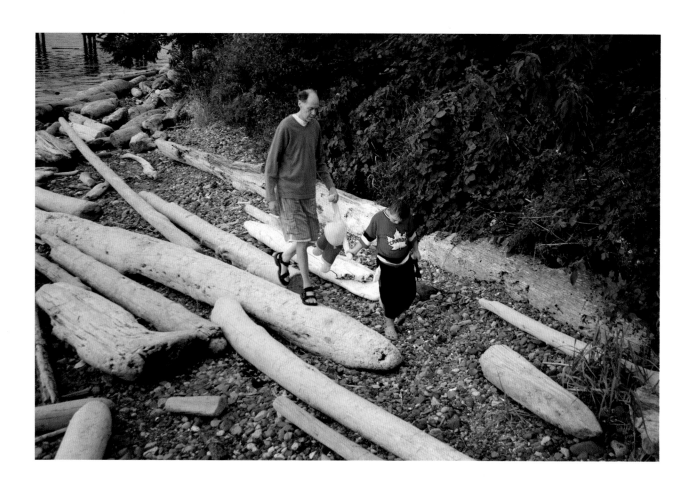

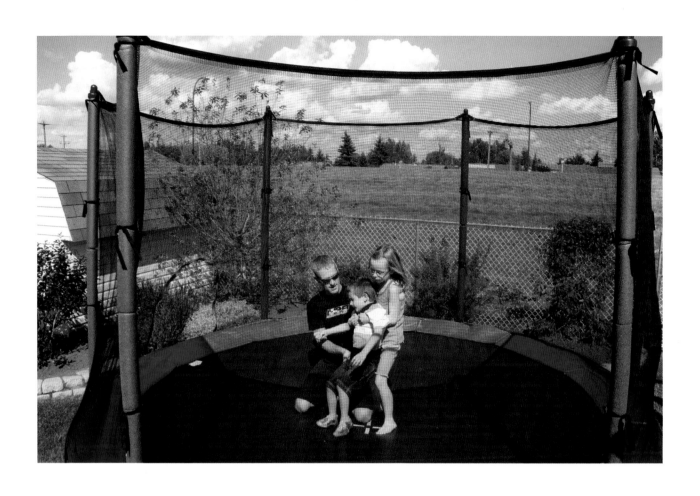

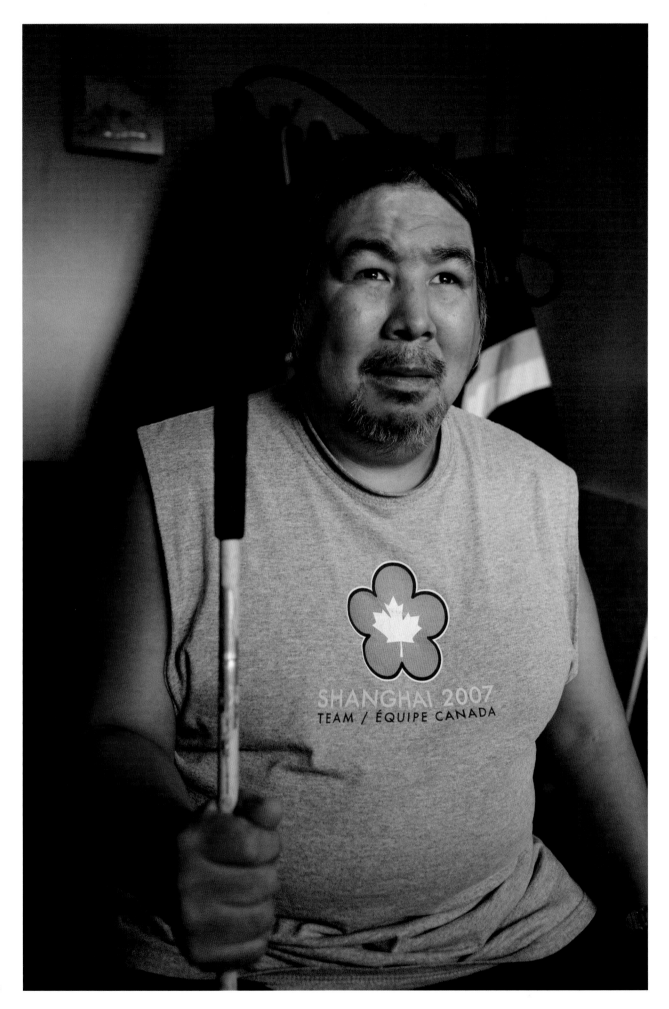

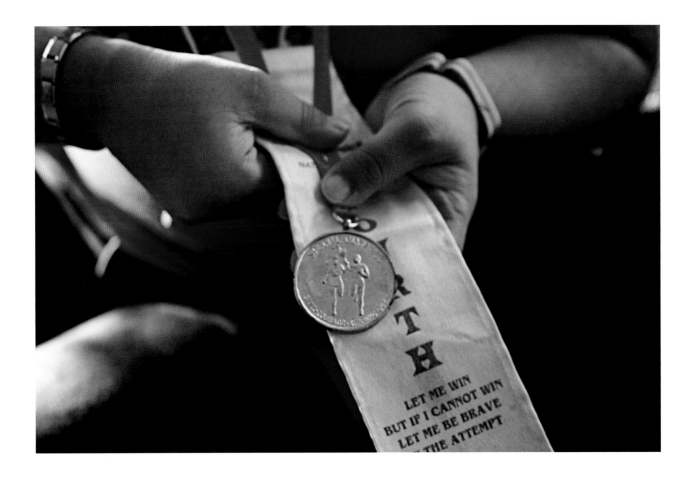

The Ice Patch

In Elm River Colony, a small Hutterite community in southern Manitoba, a group of children is playing hockey during recess on a small patch of ice on the edge of a field. It is a bright prairie morning, and the children stand out starkly against the low winter sun, especially the girls in their colorful flowing dresses and bonnets. They chase an orange-colored tennis ball with plastic hockey sticks, and scream and yell and laugh, sliding back and forth, falling over one another in sheer delight. A quintessential Canadian scene.

Except for the children, it is strangely quiet on this isolated communal farm. It is the sort of silence that comes with the days of extreme cold, when nothing stirs across the snow-covered fields or in the endless turquoise sky. The tractors are still, the nearby creek is frozen over, and the farm machinery has been silenced for the winter. The hockey game rages on, as the little bundles of passion slip and slide and roar with laughter, oblivious to me and my camera. There is a mix of ages: whoever wants to play, can play, and most take a turn even at being goalie. Does one of them seem a little slower? Perhaps, but it matters not, as the older ones do not ignore the littler ones. Nor do the faster ones ignore the slower ones, just as they've been taught. Inclusion in this community is not a concept to be understood and talked about; it is part of the natural order of things in a communal way of life. Just as everyone has joys and sorrows, so does everyone have chores and obligations, each giving his or her share according to his or her abilities.

Later that afternoon, Joshua, an eleven-year-old boy who had befriended me, gave me a comprehensive tour of the entire community. He insisted that I, his willing guest, check out the slaughterhouse, the meat-processing facilities, the dining room, the communal kitchen, the laundry, the chapel, the frozen creek. Lastly, he introduced me to his mom. He's a fine boy, she said, and he beamed with pride. His knowledge of the community was immense, and though he sometimes wasn't the quickest to chase that orange ball on the ice, it was he who had single-handedly cleared the snow and created the patch of ice where everyone could play hockey, or try out their skates.

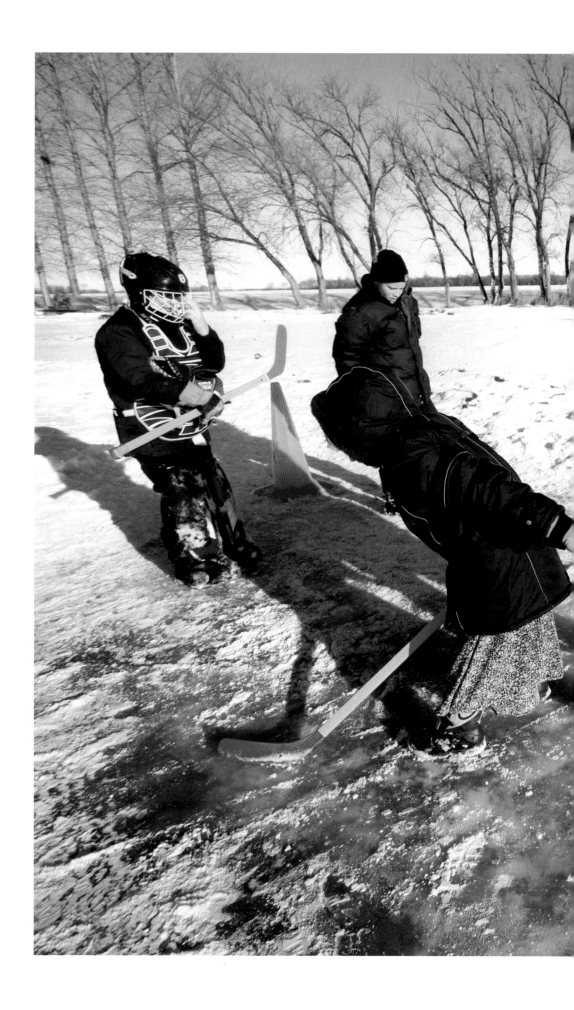

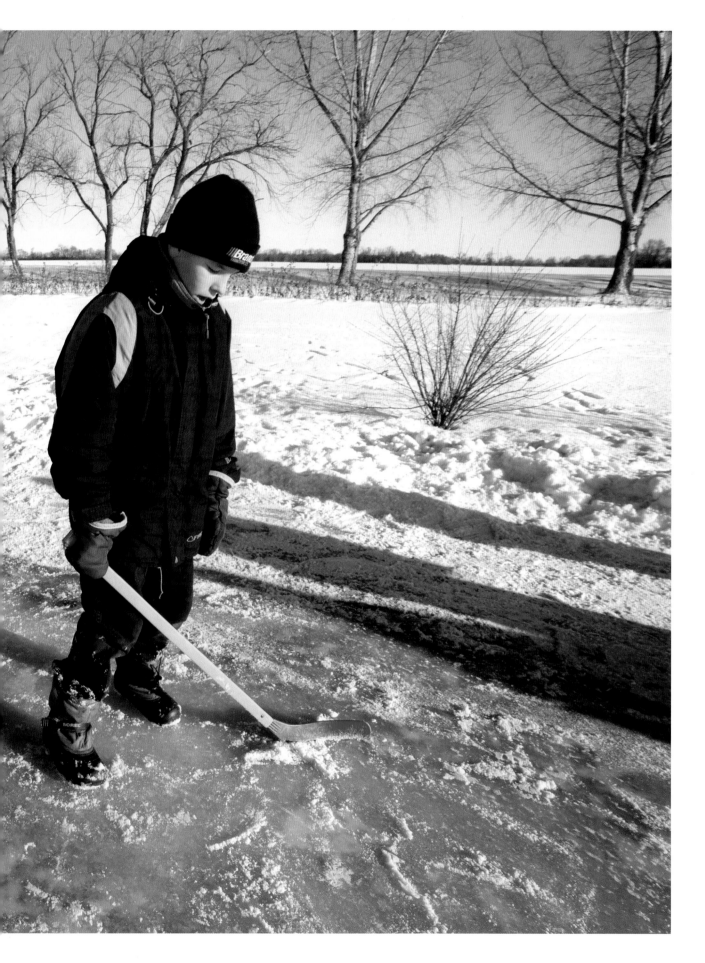

Health Care Professionals

If you have a child that is "different," you quickly find yourself entering the obfuscating world of health care culture. You end up exposing your life to a spectrum of health professionals, most of whom you didn't even know existed, but who attach themselves to you. In David's case, an infant born with forty-seven chromosomes instead of forty-six, up to twenty-three professionals worked with him at about the same time. It began with the pediatrician, then came the heart monitor, followed by the occupational therapist, the speech therapist, the infant development program. "Wherever you want to go," says his mom Deborah, "there are teams of health experts waiting for you." Each comes with support staff connected to bureaucracies of different levels of government and regulatory bodies. You, the parent, are expected to navigate through this maze—sometimes it feels more like a jungle—always mindful to respect their territoriality, not to be antagonistic toward them even when they would deserve as much, to show gratitude instead, and stoically accept their condescending attitudes. You discover that health care is not really about healing. Well, except sometimes, when you least expect it, and an angel turns up in medical garb with a gentle, understanding manner. In those moments you realize how much they could change your life, and are grateful for them.

Yes, you may be the mother or father of that "different" child, but what do you really know, madam . . . sir? Leave it to us, let us peer into your life, our team has the expertise. Sooner than you realize, you have almost adopted *them*. Strangely, sometimes it feels as if it is you who is at their service and not they at yours. Not only do you have to teach your child everything about life, you also have to educate *them* about your child. But you oblige yourself to be cooperative, you keep all the appointments no matter how routine, your life becomes a litany of visits with the team. They exhaust you, your resistance to them wears you down, but you keep going. For this is what you know: you are the lifeline for your child. You do what you have to do.

You only wish that you had a support group to help you cope with the world of health care professionals.

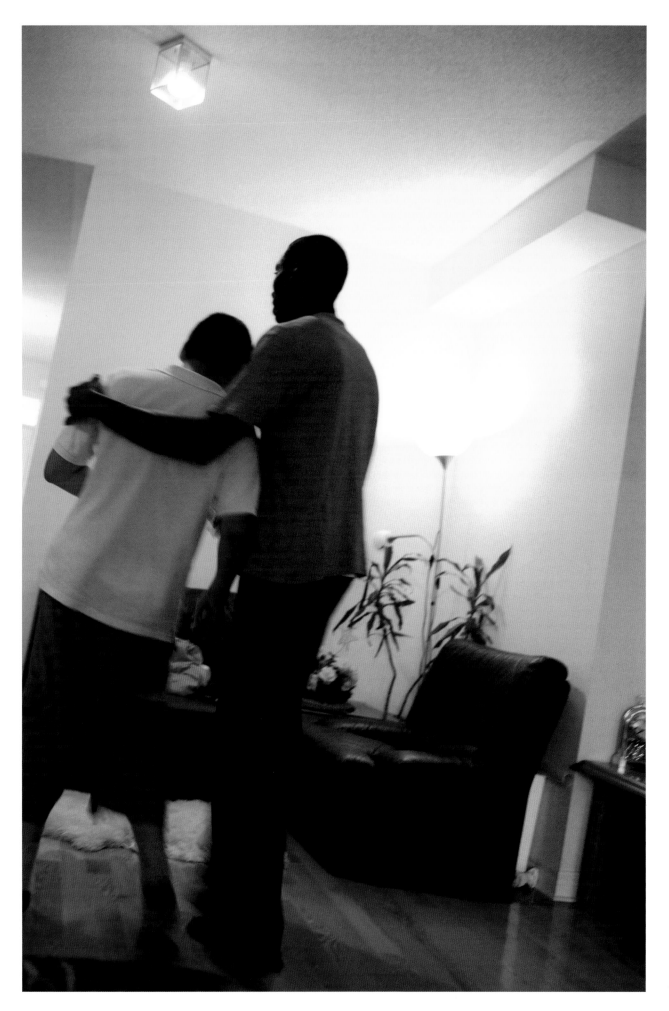

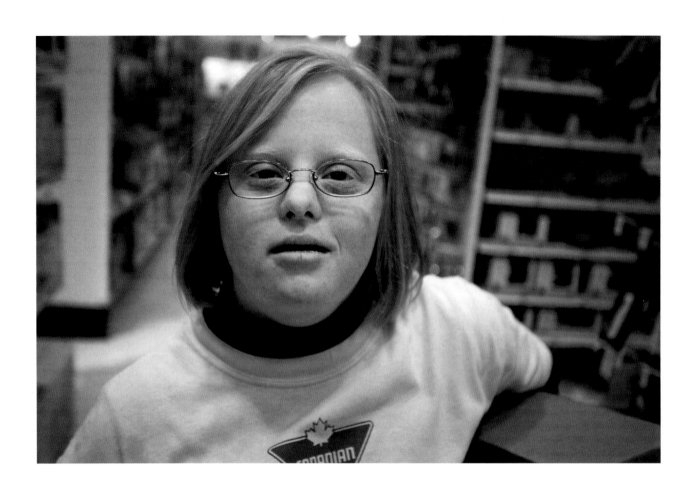

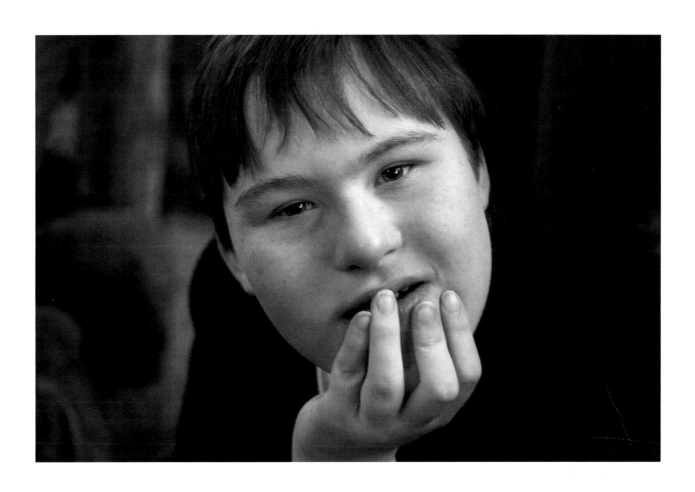

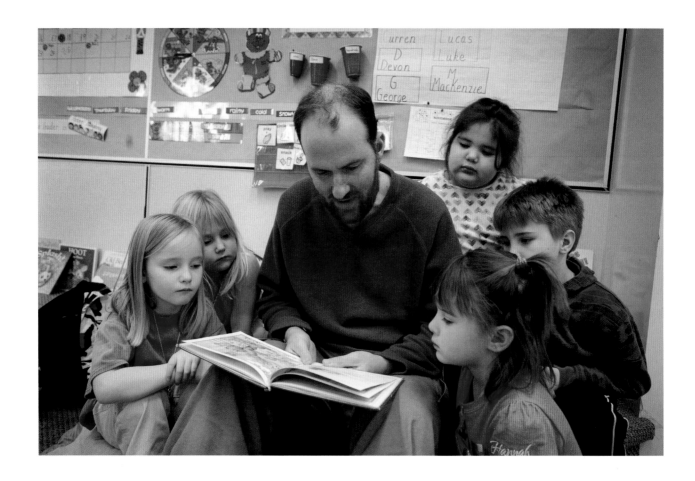

On Children's Books

Will is reading excitedly to a group of fourth grade students in Bishop Pocock Elementary School in Saskatoon, Saskatchewan. The children are held spellbound by his soothing, warm voice and by his passionate interpretation of the story. This is what he loves to do best. He has an intense fascination for children's literature, has read most of the classics, and remembers all the minutiae of details in plot, character, and scene. He can tell you the exact wording of a line from the original *Pinocchio* by Carlo Collodi, how insensitive it was of Walt Disney to change it in the movie version, and how chagrined Mr. Collodi would be if he saw it. He loves to read to children because unlike many adults he has encountered in life, children are not as exclusionary. Will's remarkable ability to memorize facts and all sorts of information is consistent with Asperger syndrome, and sometimes makes adults around him feel nervous at their own limited abilities for memorization and data retention. "I am very good at some things that most people aren't good at, but I'm not so good at some things that other people are good at." Just like the character Jiminy Cricket in *Pinocchio*, whom Will knows so well, and who says, "The right things may seem wrong sometimes, or sometimes the wrong things may be right at the wrong time, or vice versa." As a result, he has little social interaction with adults. His life has been a constant struggle between poles of inclusion and exclusion. He finds joy in children who are better at including him than "kids were when I was a kid." Will's journey is a search for opportunities to contribute. He understands better than most that in the broader society, inclusion means making room, much as people shuffle close together to allow one more passenger onto a crowded bus.

Retirement Home

The moment I met him at the Oak Leaf Retirement Home, in Columbus, Ohio, Van moved about like a "star-in-residence," full of exuberance and brimming with passion for life. It is easy to see why he is the most popular and the most energetic resident. And at fifty-seven years of age, he is also the youngest resident of the home. Technically, he shouldn't even be there. But he had always lived with his parents, Bill and Laura, distinguished peace activists who have spent a lifetime advocating for social justice. Early on they decided that their youngest son was not going to live a life hidden in institutions or secluded in group homes just because of that extra chromosome he was born with.

His birth propelled the parents even more deeply into social justice struggles, and his mother's teaching and father's work as a minister of the United Church took them to places like Japan, the Philippines, England, and across the United States. Soon they were at the forefront of the disabilities movement, long before the recent seismic shifts in attitudes. They organized seminars, study groups, and gatherings of all kinds, including a conference to mark the International Year of Disabled Persons, where "we tried to get, as much as we could, a balance between those who had visible signs of disabilities and those who didn't. . . . One day we went and took the people in wheelchairs down by the river and some of the people in wheelchairs went into the boats, and some went horseback riding. At about the end of the evening there was no sense of ability, disability, and language. It was just that. We're one. We're all the same." Van was always at their side, at the center of it all, and if the parents' mission was a "mission of inclusion," the son was its enduring symbol.

Bill steers the conversation toward an issue that weighs heavily on him and his beloved wife in these days of their advanced age: their mortality. But it isn't really their passing that weighs on them, not at all. It is their son, for "if we're not here tomorrow, he might not be able to stay here in the home." To be legally permitted on his own, he would have to be sixty-two years of age. And what kind of memorial service should they have that would make sense to Van? "We know we want cremation. . . . but Van needs to have a place where the ashes are. He would be lost if that weren't true, if he couldn't say 'Here's where my parents are.' . . . He doesn't seem to be afraid of death, or afraid of our deaths."

Sixteen days after this conversation, Bill passed away, having taken gravely ill a short time earlier. It is as if the patriarch had a premonition of his impending death. Van was very stoic at the loss of his father. He still lives with his mother, but the two have opted to move in with daughter and sister Kathy and her family on a farm in Ashville, Ohio. Bill's ashes were spread in various places sacred to the family, where they held gatherings, celebrated milestones and homecomings. At the farm that is now his home, Van is sure to feel the presence of his dad, and best friend.

Oak Tree

Yes, I remember how
we fantasized: if that
wizened old oak tree by
the Rouge River could
talk, would it tell of the
time when Eunji and
Rebecca, and Anna and
her infant child Christian
danced under its
November embrace,
how the wheelchair was
slowed by the soft
mantle of decayed
leaves that were being
slowly absorbed into the
earth?

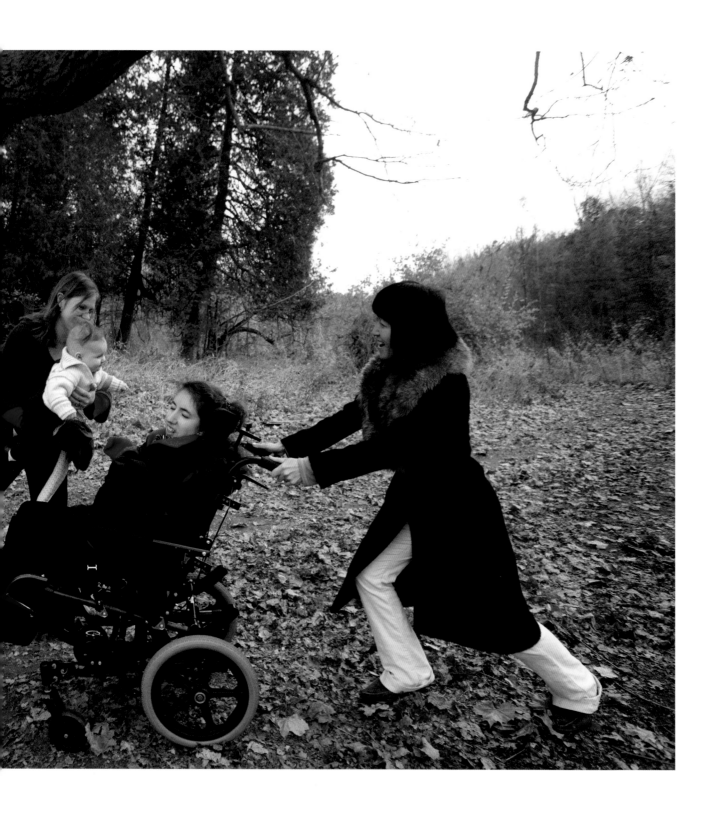

Related Resources

Brown, Ian. "The Boy in the Moon." Series of articles published in the *Toronto Globe and Mail*, December 1, 2007. http://www.theglobeandmail.com/v5/content/features/focus/boyinthe moon/.

Edelson, Miriam. *My Journey with Jake*. Toronto: Between the Lines, 2000.

Frazee, Catherine, Kathryn Church, and Melanie Panitch. *Out from Under: Disability, History, and Things to Remember*. Toronto: Ryerson University, School of Disability Studies, 2007.

The Freedom Tour. DVD. Produced and coordinated by Josée Boulanger. Winnipeg, Manitoba, 2008.

From Pillar to Post. DVD. Directed by Emery Vian. Charlottetown, Prince Edward Island: PEI People First Theatre Troupe, 2008.

Mark, Mary Ellen (photographs), Karen Folger Jacobs (text), and Milos Forman (introduction). *Ward 81*. New York: Fireside Books, 1979.

Mark, Mary Ellen (photographs), and Einar Ingolfsson (text). *Extraordinary Child*. Akranes: National Museum of Iceland, 2007.

Melberg Schwier, Karin. *Life Landscapes: Siblings Share Their Experiences of Living with Brothers and Sisters with Disabilities*. Saskatoon: Houghton Boston, 2005.

Panitch, Melanie. *Disability, Mothers, and Organization: Accidental Activists*. New York: Routledge, 2008.

Revel in the Light: The Story of Rebecca Beayni. DVD. Directed by Deiren Masterson. Scarborough, Ontario: Masterworks Productions, 2005.

Schwartzenberg, Susan. *Becoming Citizens: Family Life and the Politics of Disability*. Seattle: University of Washington Press, 2005.

Smith, W. Eugene, and Aileen M. Smith. *Minamata: The Story of the Poisoning of a City, and of the People Who Choose to Carry the Burden of Courage*. Austin, Tex.: Holt, Rinehart and Winston, 1975.

Tétrault, Pierre. *The "R" Word*. Documentary film. Toronto: OMNI Television, 2008.

Vanier, Jean. *Becoming Human*. Toronto: House of Anansi, 1998.

Index to the Photographs

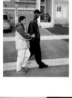
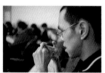
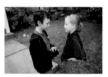
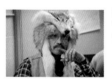
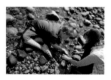
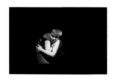
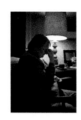

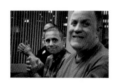

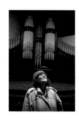
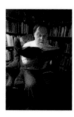
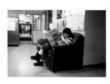
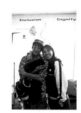
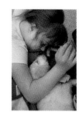
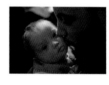
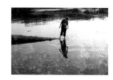
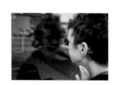
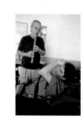
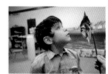
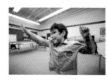

48–49. Inclusion Team, McInnes Cooper Dragon Boat Festival, Fredericton, New Brunswick, 2008.

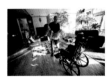
51. Joseph and Alexis Antonia Pivato, Edmonton, Alberta, 2008.

52. Marigold and Aaron Au, Richmond Hill, Ontario, 2007.

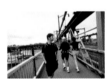
53. Ben Hildebrand, Dartmouth, Nova Scotia, 2008.

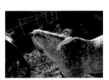
54. Jamie Martin, Nasonworth, New Brunswick, 2008.

55. Bill Shewchuck, Powell River, British Columbia, 2008.

56. Alfie McCarthy and Alice Evans, Halifax, Nova Scotia, 2008.

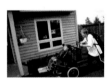
57. Danny Gallant and Nathaniel Brown, Dartmouth, Nova Scotia, 2008.

58. Debbie Gill, Charlottetown, Prince Edward Island, 2008.

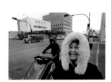
59. Bertha Taylor, Yellowknife, Northwest Territories, 2008.

61. Julian Shelton, Toronto, Ontario, 2009.

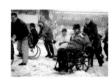
62–63. End Exclusion March to Parliament Hill, Ottawa, Ontario, 2007.

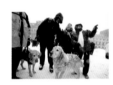
64. End Exclusion March to Parliament Hill, Ottawa, Ontario, 2007.

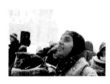
65. Rabia Khedr, End Exclusion March to Parliament Hill, Ottawa, Ontario, 2007.

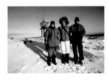
66. Dewlyn, Anna, and Diogo Lobo, Rankin Inlet, Nunavut Territory, 2008.

67. Obadiah, Marikah, Rebekka, Kaleb, and Alida Sanguin, Rankin Inlet, Nunavut Territory, 2008.

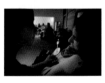
68–69. Heryka Miranda and Rebecca Beanyi, Richmond Hill, Ontario, 2008.

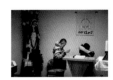
70. Jimmy Talerook and Precious Maningas, Rankin Inlet, Nunavut Territory, 2008.

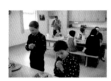
71. Alex Waldner and Joshua Hofer, Elm River Hutterite Colony, Manitoba, 2008.

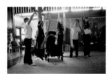
72–73. Spirit Movers Dance Troupe, L'Arche Daybreak, Richmond Hill, Ontario, 2008.

74. Donna Smith and Michael Knott, CACL 50th Conference, Ottawa, Ontario, 2008.

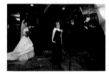
75. Twyla Derdall (model), Saskatoon, Saskatchewan, 2008.

76–77. Dancers, CACL 50th Conference, Ottawa, Ontario, 2008.

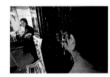
78. Melody Harlow and Ruth Reid, Winnipeg, Manitoba, 2008.

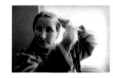
79. Carolyn MacDonald, Charlottetown, Prince Edward Island, 2008.

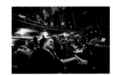
80. Van and Deborah Barndt, Columbus, Ohio, 2008.

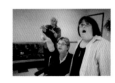
81. Vian Emery, Kim MacDougall, Tasha Adams, PEI Theatre Troupe, Charlottetown, Prince Edward Island, 2008.

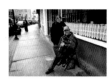

82. Karen Westcott with busker Donald Tucker, St. John's, Newfoundland and Labrador, 2008.

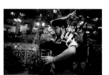

83. Max Redekop, Saskatoon, Saskatchewan, 2008.

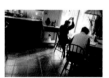

84. Ian Cole and Diana Bracegirdle, Smiths Falls, Ontario, 2007.

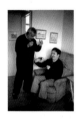

85. Charles Beaulieu and Louis Bérthiaume, Laval, Quebec, 2007.

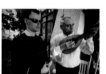

86. Bob Cherwinski and George Gorny, Winnipeg, Manitoba, 2008.

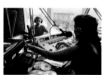

87. Darren Gerhart and Dolores de la Torre, Powell River, British Columbia, 2008.

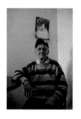

89. Neil Mercer, Saskatoon, Saskatchewan, 2008.

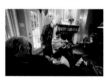

90. Christopher and Jamie Mitchinson (center) and family, Aurora, Ontario, 2008.

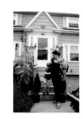

91. Alice Evans, Noah and Alfie McCarthy, Halifax, Nova Scotia, 2008.

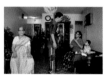

92–93. E. Annusha-mak; Kishan and Vasanthaberi Kak-agaratnam; and R. Praveena, Toronto, Ontario, 2007.

94. Danny Gallant, Dartmouth, Nova Scotia, 2008.

95. Ian Cole, Smiths Falls, Ontario, 2008.

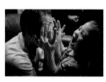

96. Michael and Gabriel Henry, Yellowknife, Northwest Territories, 2008.

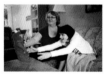

97. Suzan and Amy Jorgensen, Halifax, Nova Scotia, 2008.

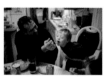

98. Kevin and Kaleb Sanguin, Rankin Inlet, Nunavut Territory, 2008.

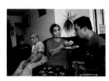

99. E. Annushamak; Vasanthaberi and Kishan Kakagaratnam, Toronto, Ontario, 2007.

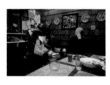

100–101. Alexis Antonia and Joseph Pivato, Edmonton, Alberta, 2008.

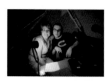

102. Majella and Daniel Collette, Shediac, New Brunswick, 2008.

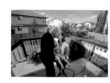

103. Chad, Jaina, and Christina Herber, St. Albert, Alberta, 2008.

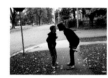

104. Luc and Anne Louise Desrosiers, Halifax, Nova Scotia, 2008.

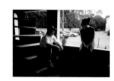

105. Ralph Silliphant and Tara Black, Fredericton, New Brunswick, 2008.

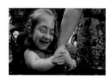

106. Carmen Sims, Edmonton, Alberta, 2008.

107. Ruth Reid and Doug Hanley, Winnipeg, Manitoba, 2008.

108. Mathieu Thibodeau, Cap-Pelé, New Brunswick, 2008.

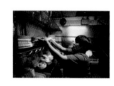

109. Mary Jane Noolook, Rankin Inlet, Nunavut Territory, 2008.

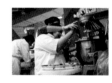

110. Meredith Allan, Aurora, Ontario, 2008.

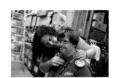

111. Carolyn Beaton and Jill Merrithew, Fredericton, New Brunswick, 2008.

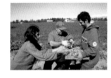

121. Antonetta, Damiano, and Vincenzo Pietropaolo, Stayner, Ontario, 2007.

133. Aaron Au and Michael, Richmond Hill, Ontario, 2007.

112. Michael Bourassa, Powell River, British Columbia, 2008.

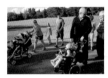

122–123. Jaina and Chad Herbers (foreground), Prince Albert, Saskatchewan, 2008.

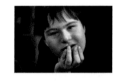

134. Elaine Hurst, Aurora, Ontario, 2008.

113. Ross Stillwell, Fredericton, New Brunswick, 2008.

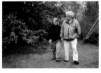

124. Gail St. Croix and Bob Mercer, St. John's, Newfoundland and Labrador, 2008.

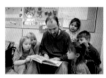

Page 135. Christopher Mitchinson, Aurora, Ontario, 2008.

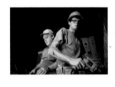

114–115. Martin Elliott and Micah Trail, Fredericton, New Brunswick, 2008.

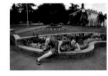

125. Richard Jones, Edmonton, Alberta, 2008.

Page 136. Will Rogers reading to Sheralee Hanson, Susan Mogenson, Leah Johnson, Brooke Joseph, Alex Bremner, Bishop Pocock School, Saskatoon, Saskatchewan, 2008.

116. Janet Robertson, Powell River, British Columbia, 2008.

126. Hal and David Douglas, Quadra Island, British Columbia, 2008.

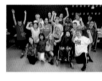

137. Grade 5 class, John McNeil Elementary School, Dartmouth, Nova Scotia, 2008.

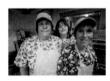

117. Gail Foder, Lisa Power, and Judy Cull, Marystown, Newfoundland and Labrador, 2008.

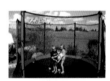

127. Quentin, Tylan, and Brooke Andrews, Lloydminster, Alberta, 2008.

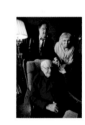

139. Van, Bill, and Laura Barndt, Columbus, Ohio, 2008.

118. Robert McGrath, Mount Pearl, Newfoundland and Labrador, 2008.

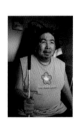

128. Terry Kuluktana, Yellowknife, Northwest Territories, 2008.

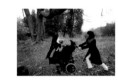

140–141. Anna and Christian Mangillo; Rebecca Beanyi; and Eunji Kim, Toronto, Ontario, 2008.

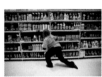

119. Elaine Hurst, Aurora, Ontario, 2008.

129. Dewlyn Diogo's Paralympic medal, Rankin Inlet, Nunavut Territory, 2008.

120. Meredith Allan, Aurora, Ontario, 2008.

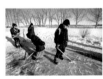

130–131. Kristofer Hofer, Alex Waldner, Daria Hofer, and Joshua Hofer, Elm River Hutterite Colony, Manitoba, 2008.

Acknowledgments

The process of creating an illustrated book, like all collaborative art projects, depends upon the involvement of a host of people as subjects or as background players. As author, one's responsibility is first to the book itself, as an expression of an idea, but that responsibility comes with deep gratitude for the many people who had a part in its making. For this book, it truly seems as if it took as many people as there are in a village.

First of all I am indebted to Michael Bach and Doris Rajan, executive vice-president and director of Public Education and Social Development, respectively, of the Canadian Association for Community Living (CACL), who in January 2007 invited me to develop a proposal for a photography book on people with intellectual disabilities, ostensibly to mark the fiftieth anniversary of the organization one year later. The terms were simple: they would provide logistical assistance through their network of local organizations across the country, some initial development funds, and also organize fund-raising activities to cover travel expenses and fees. My relationship with them has been completely at arm's length with respect to editorial or artistic decisions. Throughout the lengthy process, they were very supportive, and quite simply have been the pivotal force behind the book. That support has come with the full cooperation and blessings of both Zuhy Sayeed, the president of CACL when I started the project, and her successor and current president, Bendina Miller.

I am deeply grateful to Catherine Frazee of Ryerson University, who has kindly contributed an original and illuminating essay. I am also grateful to Wayne Johnston, who has kindly written the foreword. I would like especially to acknowledge Leslie Mitchner, associate director/editor in chief of Rutgers University Press, who immediately saw the relevance of the book and agreed to publish it and has persevered with patience and understanding through delay after delay during the lengthy process.

There are a number of individuals who played a crucial role at different points, and whom I would like to thank warmly: Jennifer Mitchinson, who was instrumental in introducing me to the world of intellectual disabilities, assisted me with initial contacts for photography, spearheaded organizing efforts such as the fund-raising dinner at Grano Ristorante in Toronto, and opened up her home and family to my camera; Lu Barbuto and Janice Law, who generously sponsored the dinner in collaboration also with Magnotta Wines; Roberto and Lucia Martella, and Flora Martella of Grano; Pierre Tétrault, executive producer and director of *The "R" Word*, who invited me early on in the process to join his crew as they filmed people with intellectual disabilities; Lilla Lipton of the Powell River Association for Community Living, who hosted me in her home in Powell River; Deborah Douglas, who hosted me in her home in Quadra Island; Lynn Akmens of the New Brunswick Association for Community Living (NBACL), who hosted me in Fredericton; Normand P. Robichaud of NBACL, who hosted me in Shediac and Cap-Pelé; Jacqueline Ducey of the Burin Peninsula Supported Employment Services, who hosted me in Marys-

town; Julie Whyte of the Yellowknife Association for Community Living, who hosted me in the Northwest Territories; Yvonne Cooper of the Pamiqsaiji Association for Community Living (in the Taparti Centre), who not only hosted me in Rankin Inlet, but kindly funded that portion of my trip; Kathy and Tom Brownfield, who hosted me in Ohio; Lynn Schaan of the Saskatchewan Association for Community Living, who hosted me in Saskatoon and also looked after my accommodations; and Elma Maendel, who hosted me in the Elm River Hutterite Colony.

I am particularly indebted to Barbara Sibbald and Jim Aquila, friends who read early drafts of my manuscript and offered valuable suggestions.

My wife, Giuliana Colalillo, as always, has been involved in most facets of the project, including artistic feedback, technological assistance, and practical support. Without her tireless help the book would not have been possible.

. . .

I would also like to the following individuals and organizations who facilitated access to their premises, workplaces, and events where I was able to photograph unhindered, and, as well, to the individuals and families whom I photographed, interviewed, or who offered me invaluable insights, advice, or support. (Note: The provinces, territories, and names listed below are organized largely in the order I visited or consulted them.)

Ontario: Sidnaiak, Vasanthaberi, Kishan, and Karthiga Kakagaratnam; R. Praveena; E. Annushamak; Marigold, Aaron, Joyce, and Jolie Au; Audrey and Ian Cole; Marsha McKenna; Diana Bracegirdle; Christopher Mitchinson and his extended family; Meredith Allan; Dominion Store, Aurora; Elaine Hurst; Canadian Tire Aurora; Damiano, Antonetta, and Vincenzo Pietropaolo, Fergus; Susan and Rebecca Beanyi; Rocco Rossi, Ontario Heart Foundation; L'Arche Daybreak; Donna Smith and Michael Knott; Aileen Dawkins; Sharon and Julian Shelton; the Spirit Movers; Osamu Shynia, Lesley White, Jessamyn Looyenga, Heryka Miranda, Andreas Prinz; Joy Sumyi Lee; Nicole Woodman Harvey; Bianca Javairaim; Jessica Leslie; Jordan McLurbin; Jonathan Alexander; Eunji Kim; Tracy Westerby; Anna MacLean; Becky Till; Anna and Cristian Mangillo; Jihanne Allam; Ottawa School of Art; Genoveva Ibarra; Liane Regendanz; Katherine Fletcher; Deborah Barndt; Magdalene Winterhoff; Kingsley Gilliam.

Québec: Paulette and Louis Bérthiamue; Charles and Lorette Beaulieu; Nathan and Roch Séguin.

New Brunswick: Danny Soucy and Lynn Akmens, New Brunswick Association for Community Living; Evan MacInnis, Canadian Sport Centre; McInnnes Cooper Dragon Boat Festival; Shannon Jardine, Sport New Brunswick; Calvin Bradley, Jobs Unlimited; Canadian Tire, Fredericton; Zellers, Inc., Fredericton; Robert Hay, Trius Disposal Systems Ltd; Brad Janes, Fredericton Region Solid Waste Commission; Callander Hall Equestrian Center; Radio Beausejour, Shediac; Edmond Gagnon Ltd; Daniel Crossman; Britanny and Kyle Akmens; Amy Munn; Susanne and Gerry Hill; Byron McGinnis; Micah Trail; Martin Elliott; Jill Merrithew; Carolyn Beaton; Stephanie Hayden; Ross Stillwell; David Eric Young; Lorraine and Ralph Silliphant and family; Jamie Martin; Mathieu Thibodeau; Simone Melanson; André Landry; Bobby Duguay; Dominique Le Blanc; Daniel, Majella, and Richard Collette.

Nova Scotia: Mary Rothman of the Nova Scotia Association for Community Living; Jennifer and Danny Gallant; Nathaniel Brown; Timothy Jackson; John McNeil Elementary School, Dartmouth; Lori Watkins; Suzan and Amy Jorgensen; Ben, Larry, and Judy Hildebrand; Alice Evans; Noah and Alfie McCarthy; Sara Cole; Luc, Anne Louise, and Jacques Desrosiers; Olivia and Caroline Dobson; John Walker.

Prince Edward Island: Carolyn Macdonald and Ann Wheatly, PEI People First; Vian Emery, Kim Macdougall, Tasha Adams, Kevin Ramsay, and Norman Pickering; Gordie Arsenault of PEI Theatre Troupe; Doug Young, Smoked and Specialty Products; Shaun Macdonald; Glair Fanning; Debbie Gill; Sue MacDonald; Critter's Pet Shop.

Newfoundland and Labrador: Brianna Hookey, Newfoundland and Labrador Association for Community Living; Independent Living Resource Centre, St. John's; Avalon Employment Agency; Don Gallant; Karen Westcott; Gail St. Croix; Bob Mercer; Robert McGrath; Robert McGuire; Judy Cull; Gail Foder; Lisa Power; Johnny Auld.

British Columbia: David, Olivia, Luc, and Hal Douglas; Harvey Chometsky, IDEA Gallery; Michael Bourassa; Shinglemill Restaurant and Pub; Dale Eckert and Angela Seeley; John Tyler and Andre Cusin, Golden Residence (PRACL); Jim Douglas; Shannan Ollson; Moose and Eddy's Bar; Dolores de la Torre, JUMP Radio (Powell River Model Community Project for Persons with Disabilities); Bill Shewchuck; Darren Gerhart; Victor Efimoff; Janet Robertson; Peter Mitchell, Mitchell Brothers Grocery Store; Jane Davidson.

Yukon: Julien Richard and Theresa Roberts; Jordan Coombes; Rebecca Barichello; Marge Macleod, Fetal Alcohol Syndrome Society of Yukon; Sky High Wilderness Ranch; Norman Drynock, Executive Director, Committee on Abuse in Residential Schools Society.

Alberta: Norman and Kathy McCleod; Raffath Sayeed and family; Emma, Joseph and Alexis Antonia Pivato; Christina, Chad, and Jaina Herbers; Richard Jones; Nina Haggerty Centre for the Arts; Carmen, Ashley, Mary-Lou, and Ed Sims; Stacey, Quentin, Brooke, and Tylan Andrews.

Northwest Territories: Eva Charlo; Bertha Taylor; Shauna, Michael, Gabriel, and Jack Henry; Alison Barr; Terry Kuluktana; Phoebe Tbse; Alex Siksik, teacher at Simon Alaittuq School, with students Iga Abgoo, Tasha Anawak, Tristan Sammurtok, Heather Boucher, and Sandra Manevnaluk.

Nunavut: Anna, Diogo, and Dewlyn Lobo; Kevin, Alida, Obadiah, Marikah, Rebekka, and Kaleb Sanguin; Arthur Lebsack; Alistair Harvey; Siniktarivik Hotel; Pauline Fontaine; Maurice and Mercedes Pipak; Jimmy Talerook; Travis Niptanatiak; Clayton McCskills; Helen Akerolik; Joannaise Aupluak; Pleagie Arnatasiq; Mary Jane Noolook; Elisapee Pitseolak; Julie Millen—SST, Leo Ussak School; Mary Ann N. Maningas and daughter Precious; Rev. Joseph Meuus, Our Lady of the Cape Church.

Saskatchewan: Lynne Harley; Sheila Anderson; Cornerstone Church; Twyla Derdall; Crystal Morrissette; Christopher Boyer; Sam Sambasivan, Construction Fasteners & Tools Ltd.; Neil Mercer; Jordan Upshall; Kristi St. Laurent; Moxiel's Restaurant; Lorraine and Max Redekop; Kelly Cotter; Tina Friesen; Sherralee (Kelsey) Hanson; Susan Mogenson; Leah Johnson; Brooke Joseph; Alex Bremner; William Rogers; Saskatoon Inn and Conference Centre; Carol Sarich, principal, and Jackie Kjargaard, teacher, at Bishop Pocock School, Saskatoon; Lindsay Chalmers; Richard Kenny; Evgeny Miroshnichenko; Saskatchewan Institute of Applied Science and Technology—Kelsy Campus.

Manitoba: Rose Flaig, Community Living Manitoba; Judy Andrich, Hope Centre Inc.; Deb Loewen; Bob Cherwinski; Doug Hanley; Melody Harlow; Ruth Reid; Kathie Walters; Marilyn Whincup; Vanessa Ducharme; Rachel Wallace; Valerie Wolbert; Joshua Hofer; Kristofer Hofer; Daria Hofer; Alex Waldner; Robert Maendel; Linda Maendel; Karen Maendel; Herby Hofer; George Gorny.

In addition—

Italy: Manuela Fugenzi and Stefano Andretta.

United States: Bill, Laura, and Van Barndt; Oak Leaf Retirement Home, Columbus, Ohio.

End Exclusion March to Parliament Hill, Ottawa, Ontario, 2007

NOTE ON THE AUTHOR/PHOTOGRAPHER AND CONTRIBUTORS

Vincenzo Pietropaolo is a documentary photographer and writer who has been exploring social issues for over thirty years. His artistry and social commitment have won him widespread recognition. Aside from exhibiting frequently, he has published seven previous books of photography, including *Harvest Pilgrims: Mexican and Caribbean Migrant Farm Workers in Canada.*

Catherine Frazee is a Canadian educator, activist, researcher, poet, and writer who currently serves as a Professor of Distinction in the Disability Studies program at Ryerson University as well as a codirector of Ryerson University's Institute for Disability Studies Research and Education. She is a former chief commissioner of the Ontario Human Rights Commission.

Wayne Johnston is a celebrated Canadian author of *The Colony of Unrequited Dreams* and *The Custodian of Paradise.* Since 2004, he has held a Distinguished Chair in Creative Writing at Hollins University in Virginia. For *Baltimore's Mansion*, a memoir, he received the Charles Taylor Award, the most prestigious prize for nonfiction in Canada.